I Dream HORSES

by Linda Dalziel

SHARE YOUR BEAUTIFUL CREATIONS!!

Come and visit the **I Dream HORSES** Facebook page at:
http://www.facebook.com/idreamhorses
to see how this coloring book was created,
and to *share* your beautiful work!

To see Linda's **Horse Spirit Paintings** visit:
http://www.facebook.com/thehorsespiritartist

If you would like to be the first to get **Linda Dalziel** updates,
see her latest illustrations, published books, horse wreaths,
or any new paintings and have priority purchasing, then
YOU ARE CORDIALLY INVITED
to join the private facebook group:
THE ART OF LINDA DALZIEL

For additional information visit **www.ArtForMyAnimals.com**

ALL RIGHTS RESERVED. NO PART OF THIS BOOK MAY BE REPRODUCED
IN ANY FORM
without written permission of the copyright owner.
Every effort has been made to ensure that all credits accurately comply
with the information given.
Printed in the U.S.A.

Copyright c 2016 Linda Dalziel
All rights reserved.
ISBN: 10:1540329402
ISBN: 13:978-1540329400

Gather your art supplies and get ready to color!

There is no limit to what you can use to color these beautiful pages. However, there are some precautions to take to ensure your stunning masterpieces makes your heart sing!

There was only one choice of paper provided by the publisher for the printing of this book. So before you go straight to coloring, I have provided some test pages in the back for you to experiment on. Be sure to put a heavy piece of paper under the page you are going to color, because some markers or paints may bleed thru.

Colored pencils, crayons, and gel pens might work best. But by all means explore and find your creative side!

Whatever you choose I know it will be beautiful because YOU are coloring them.

And now, let your inner Dream Horse guide your way!

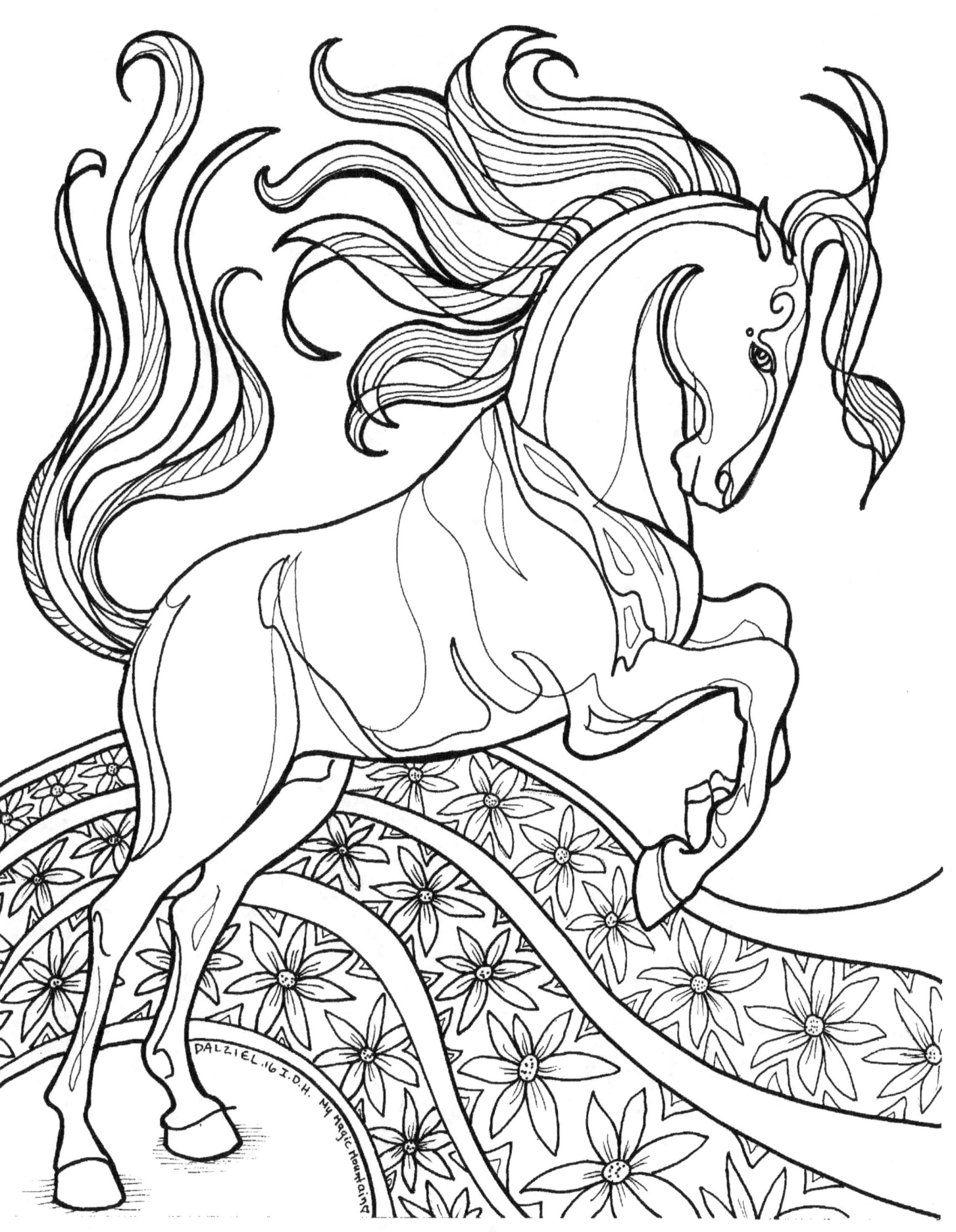

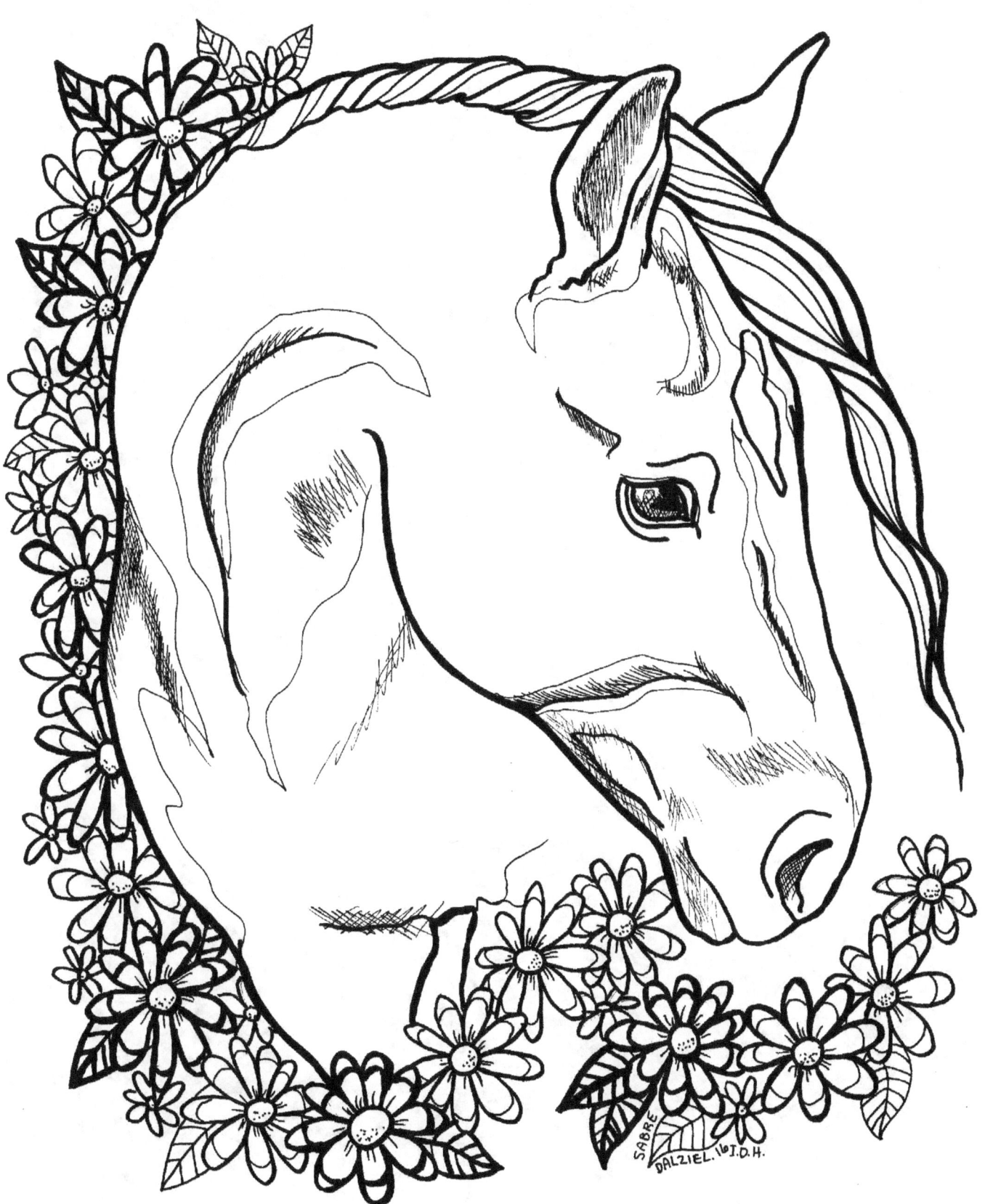

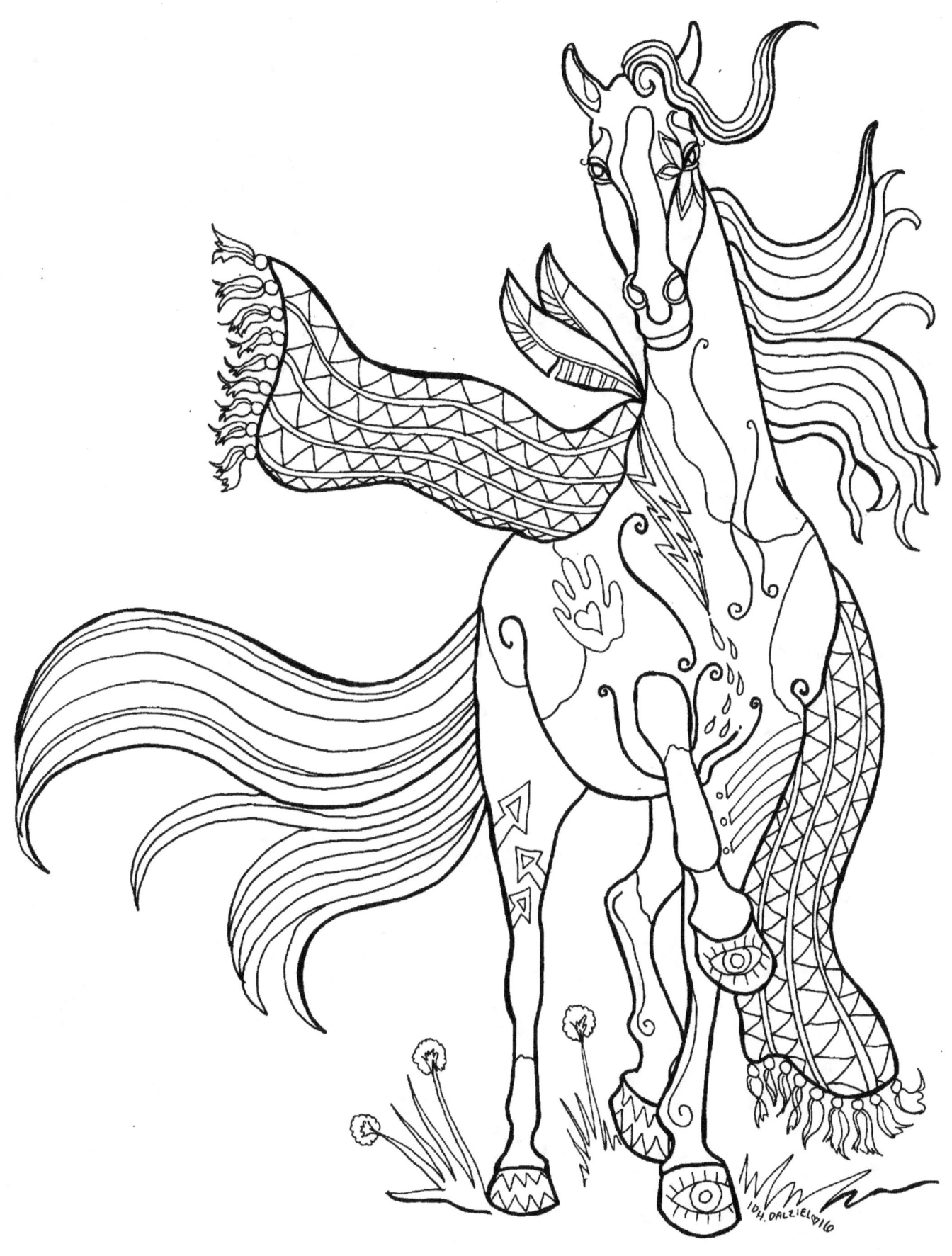

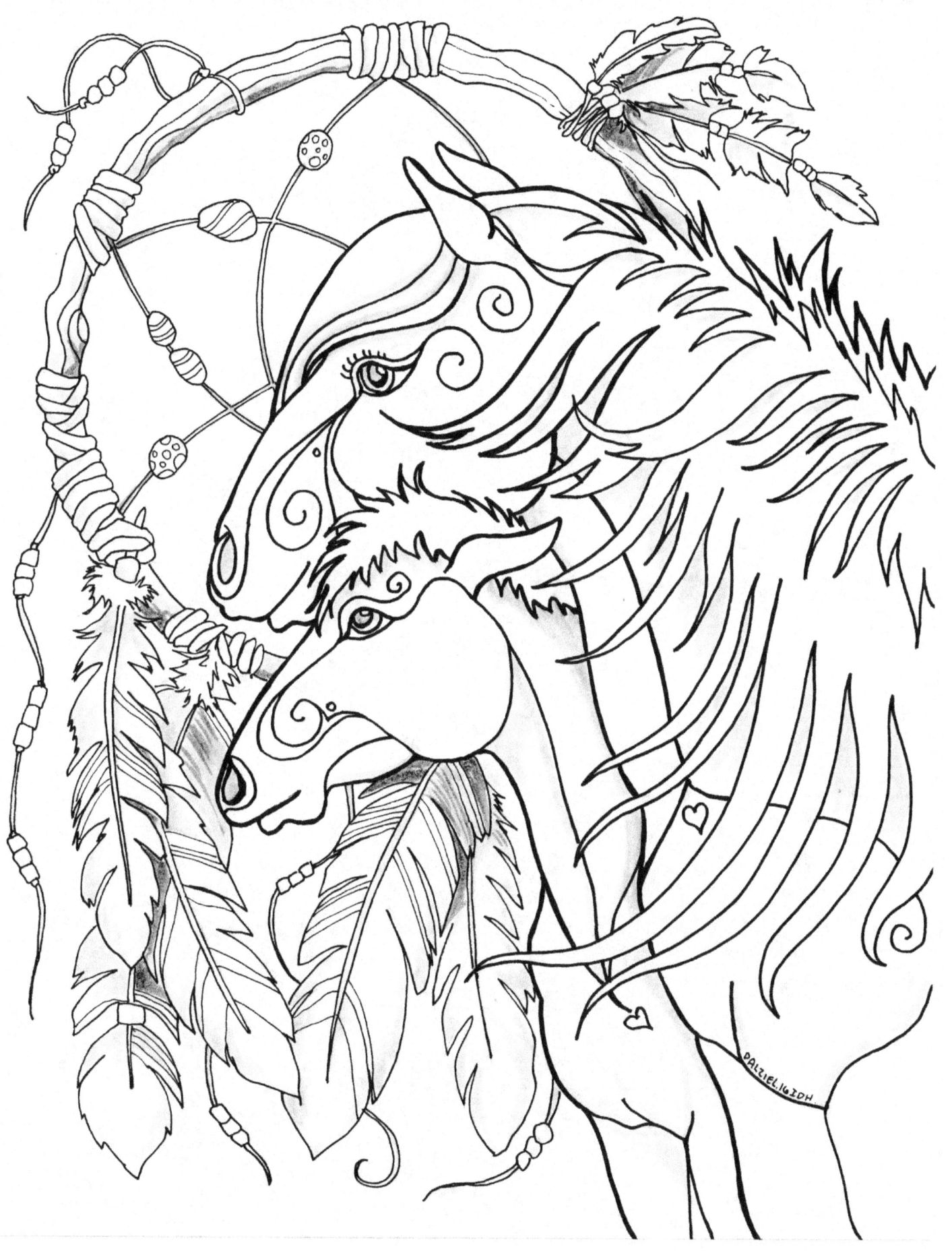

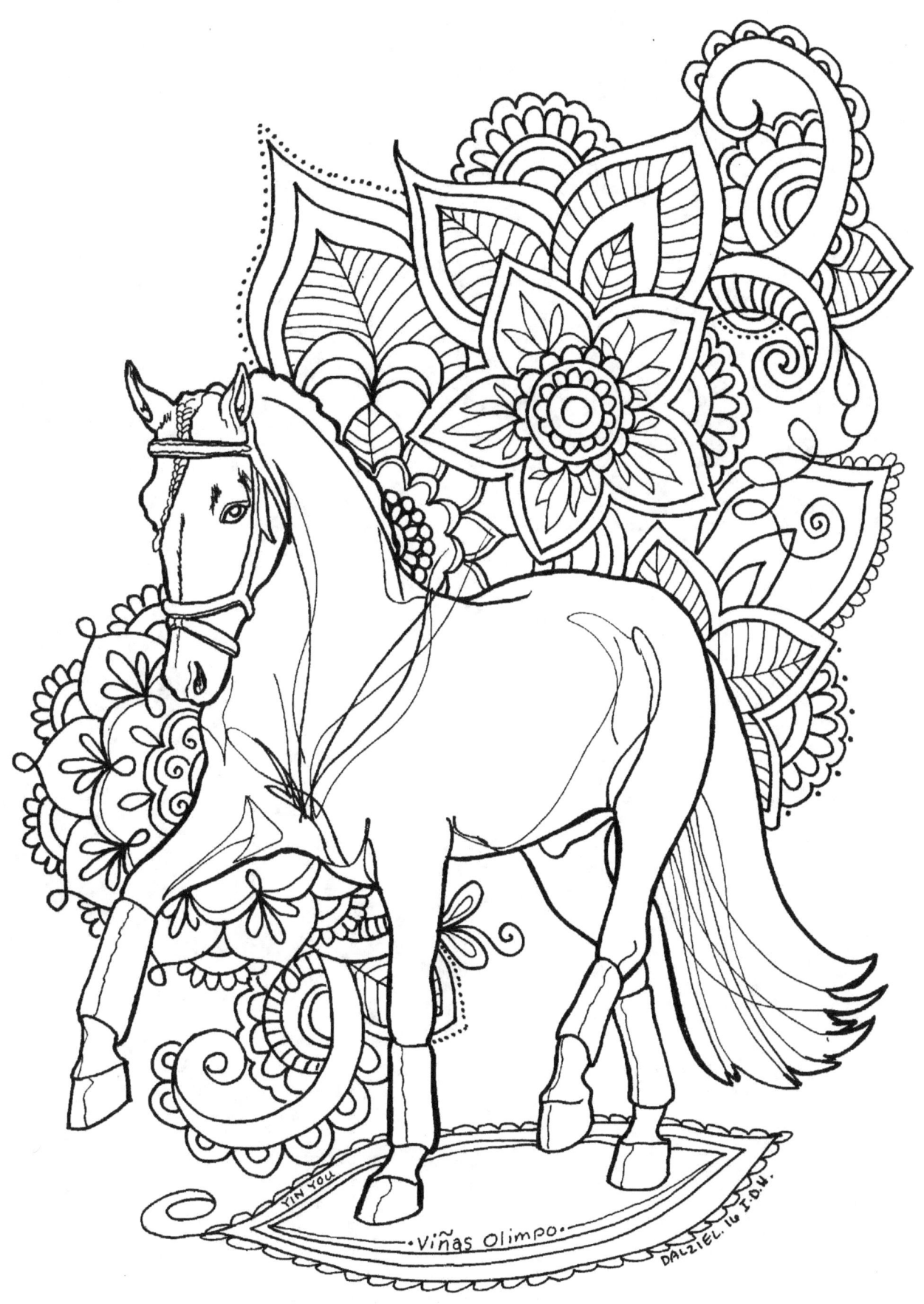

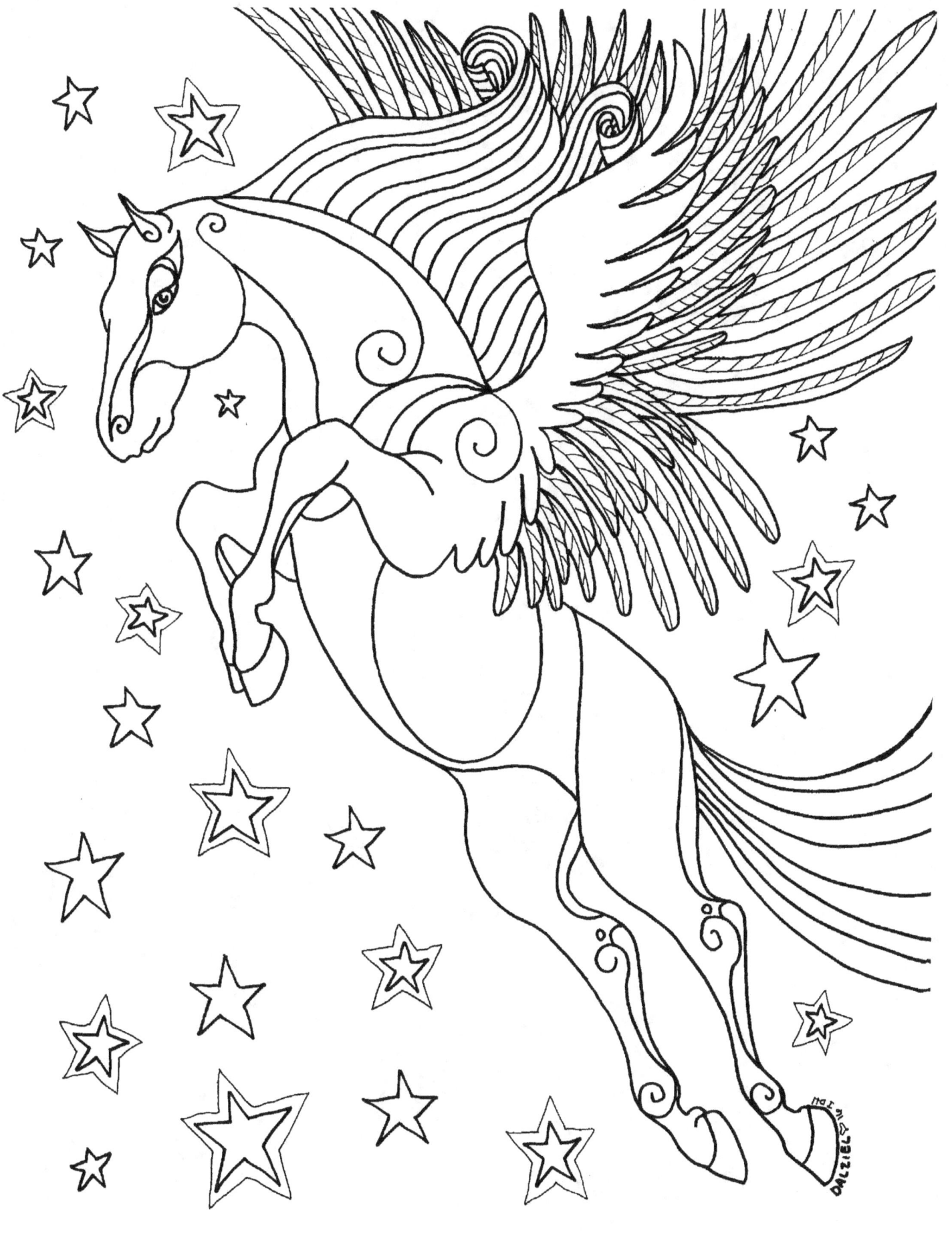

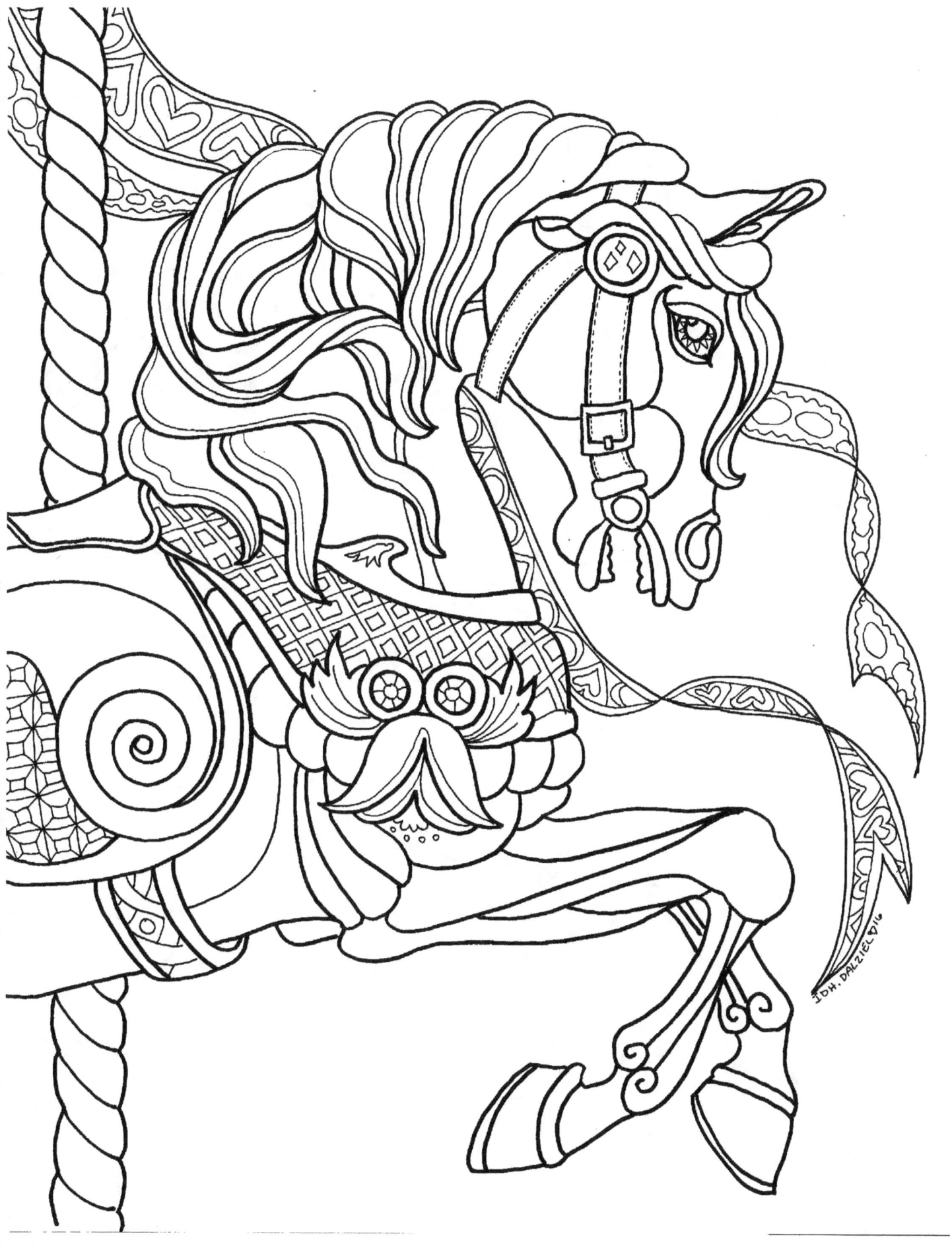

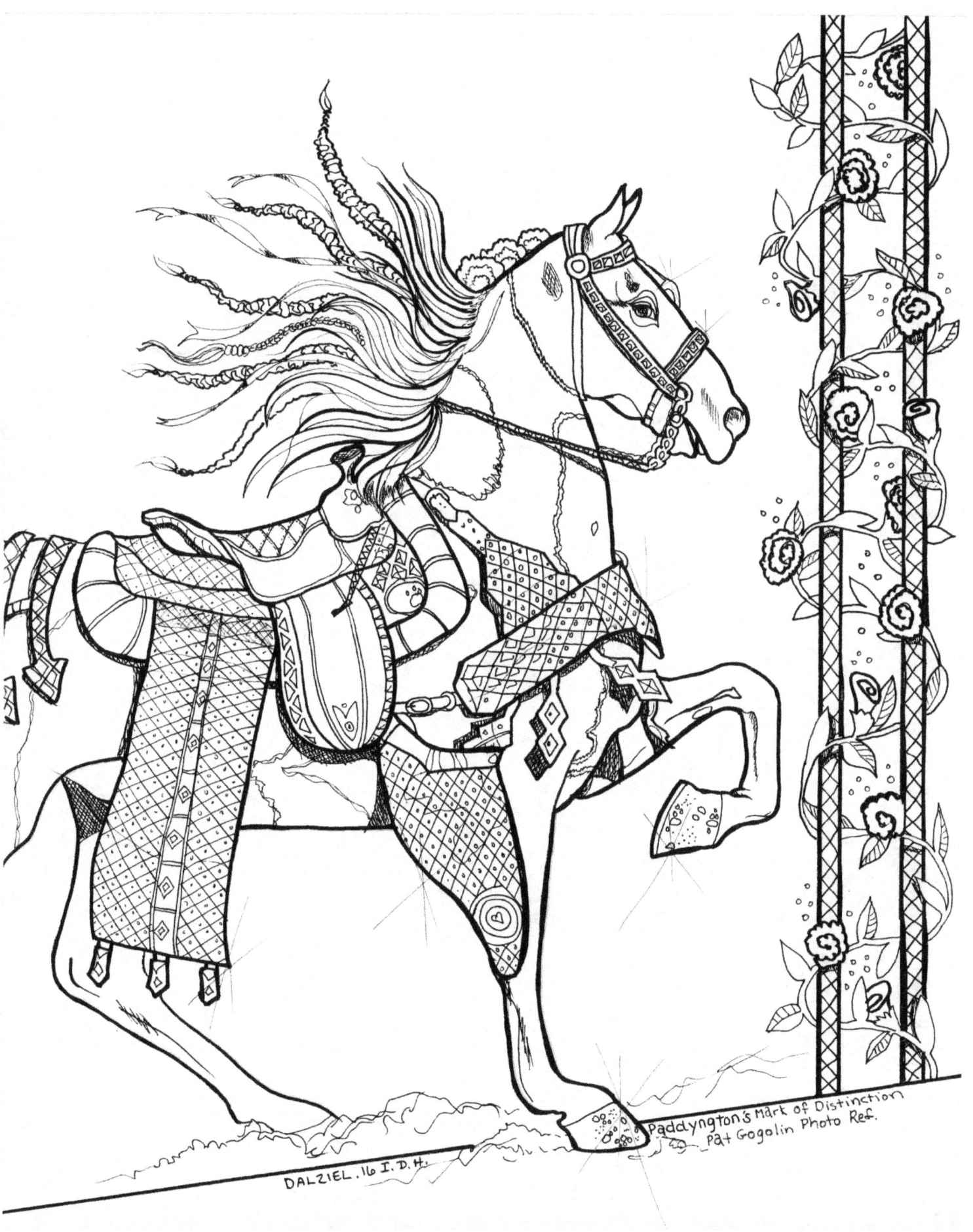

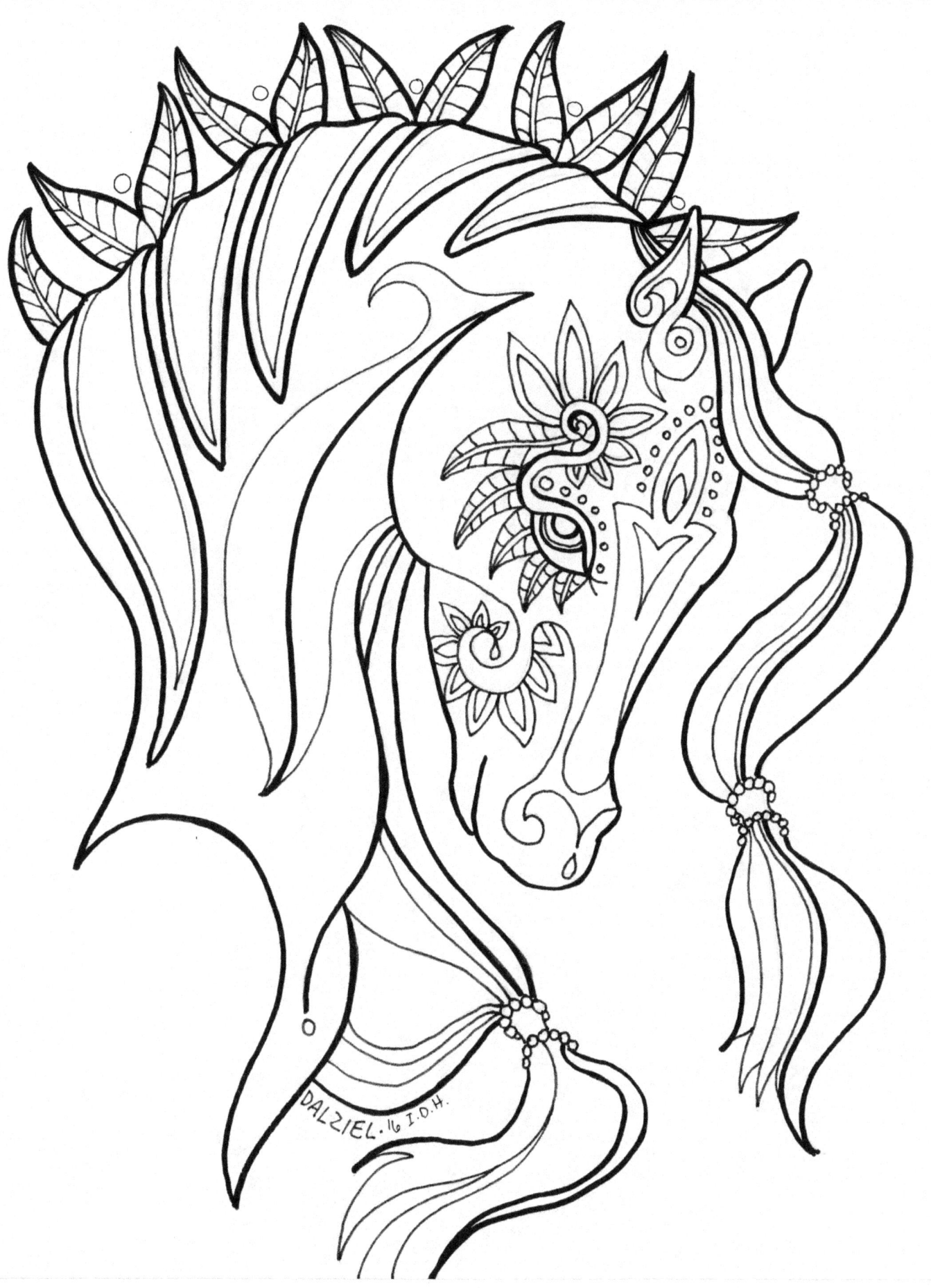

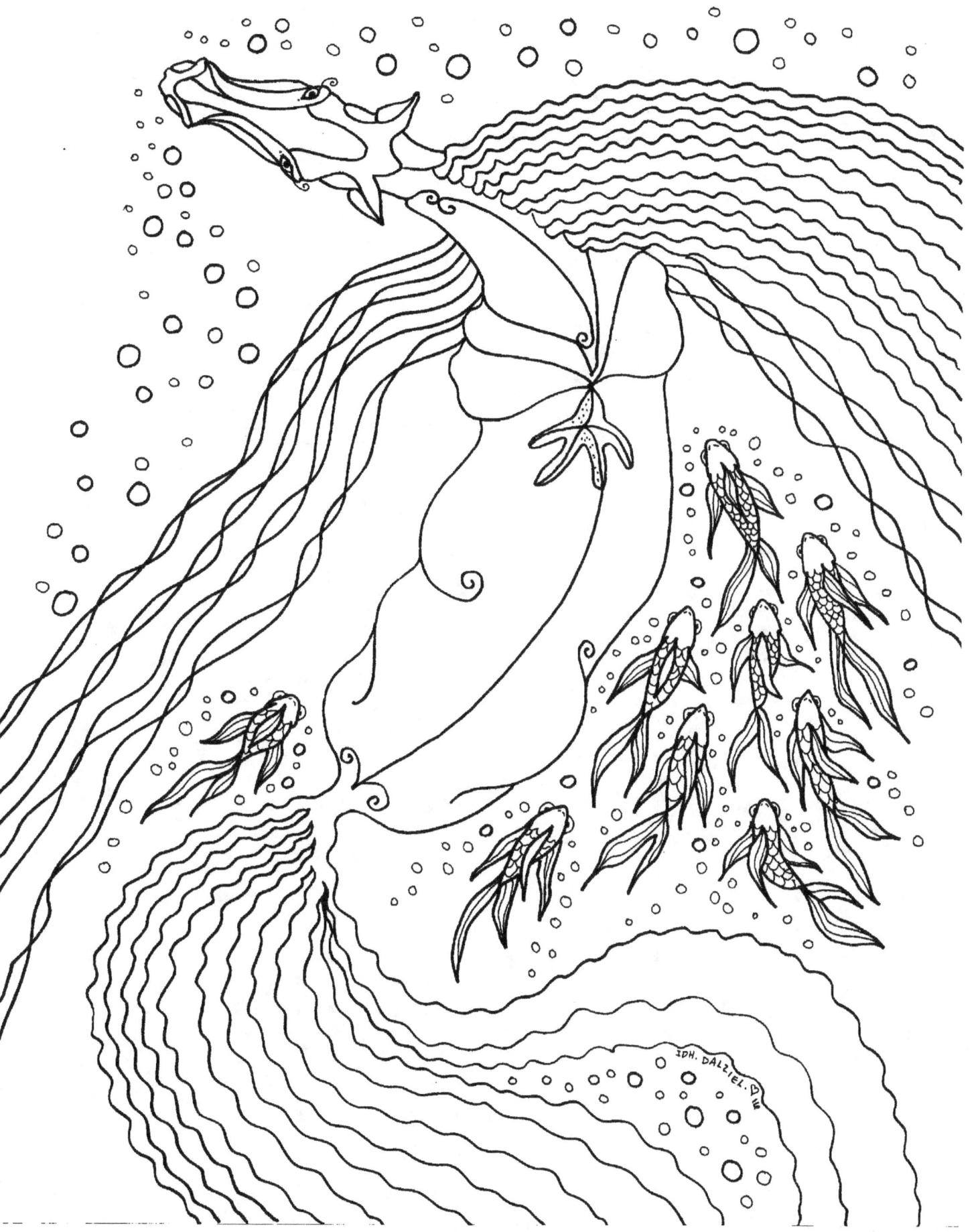

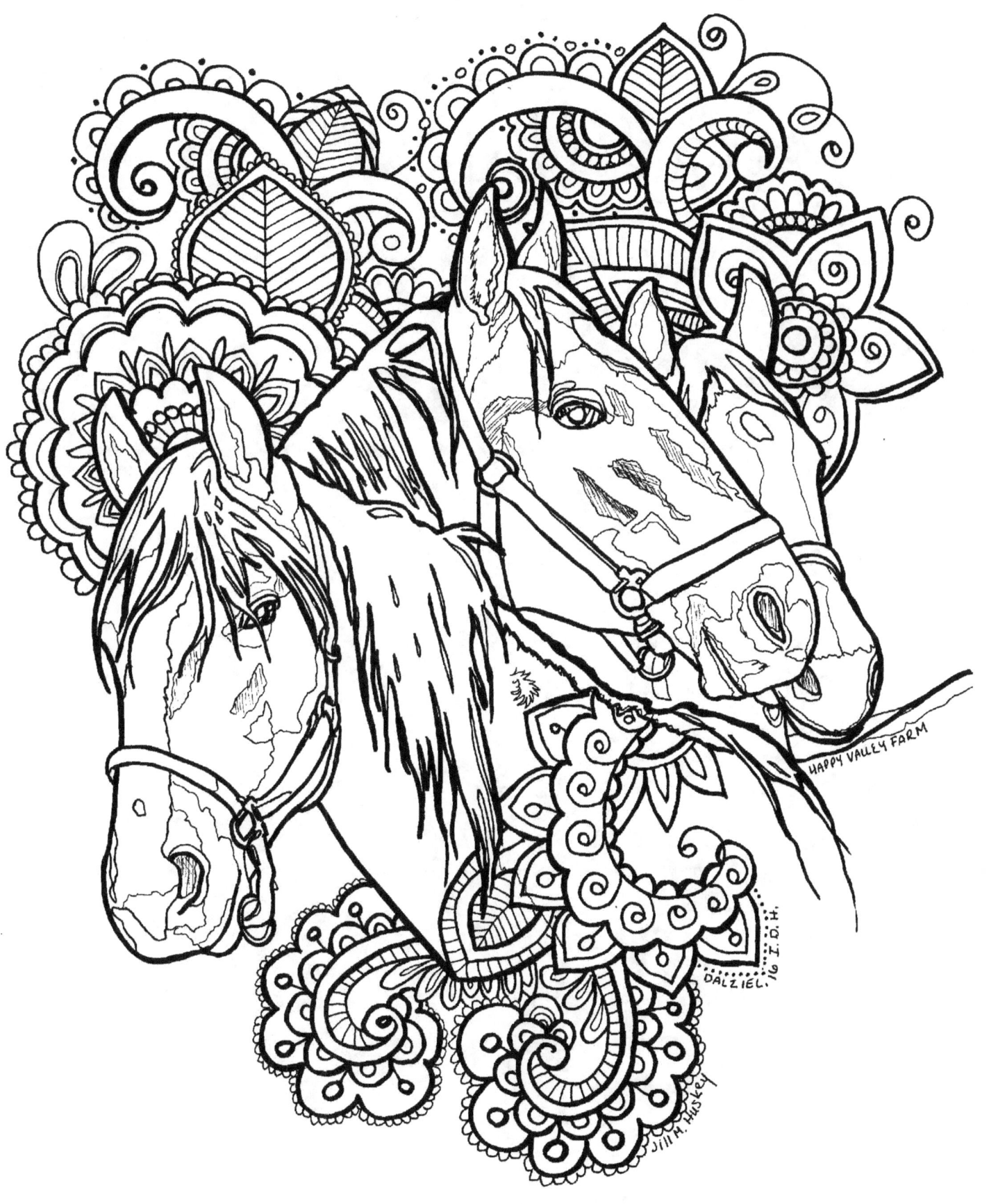

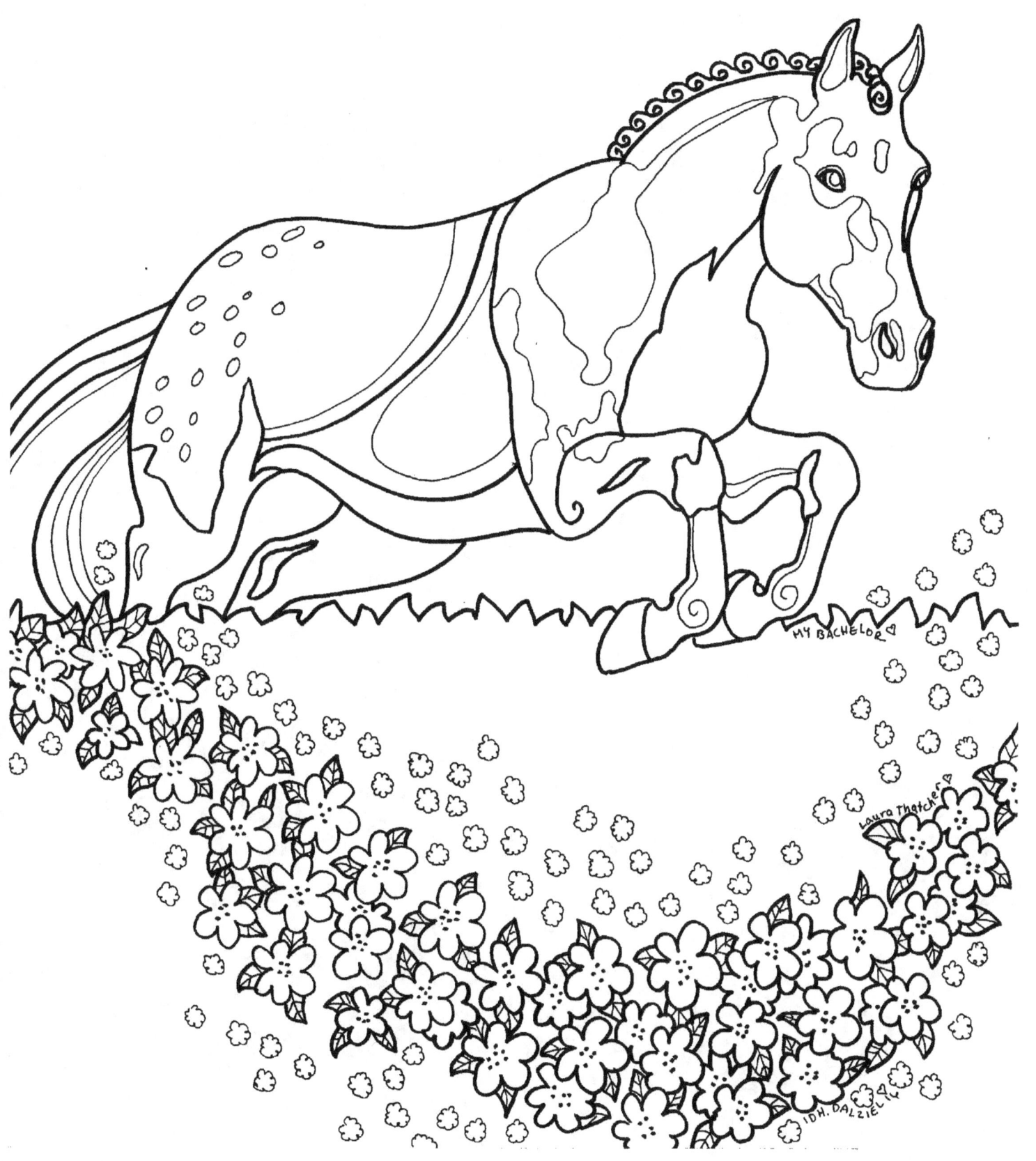

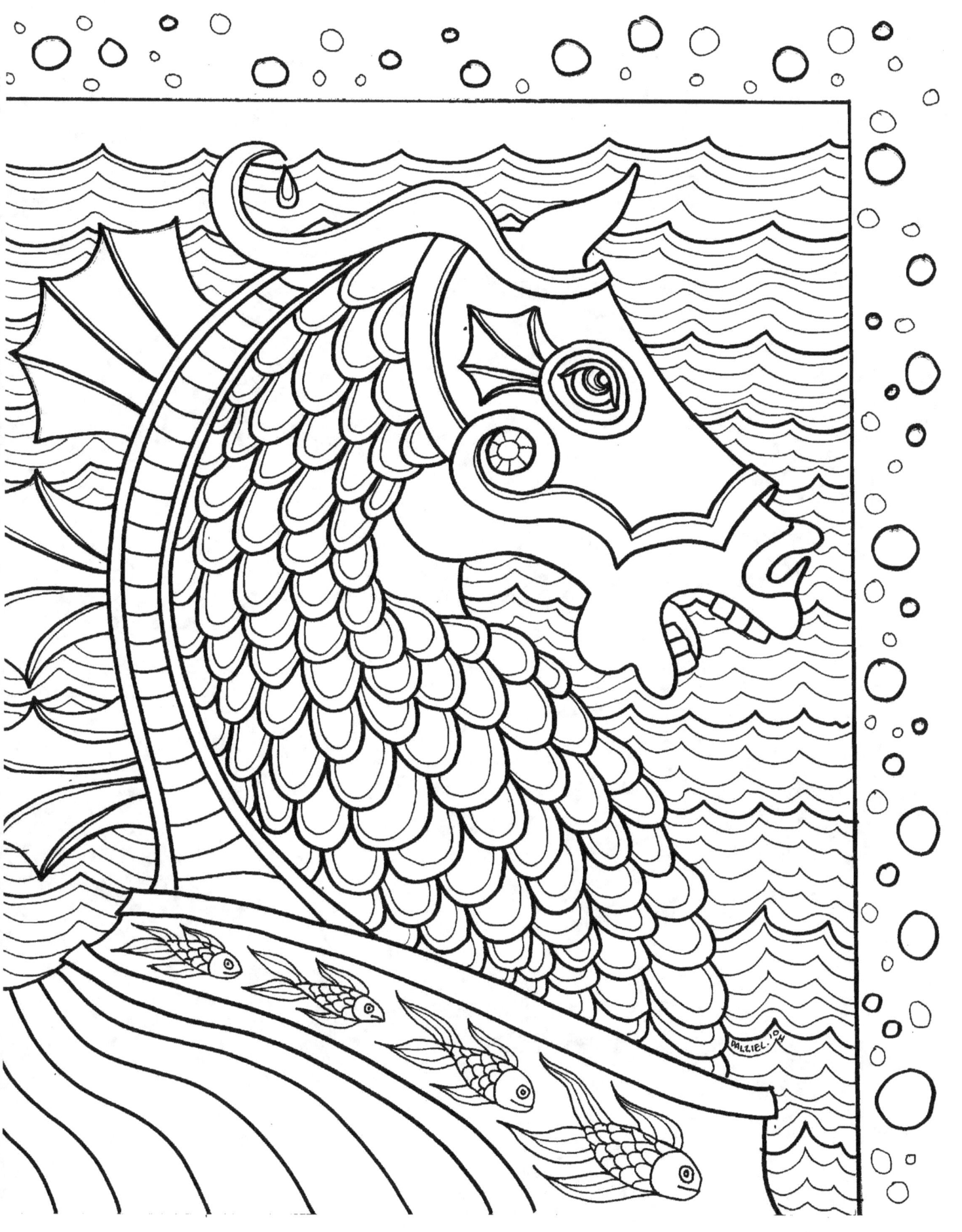

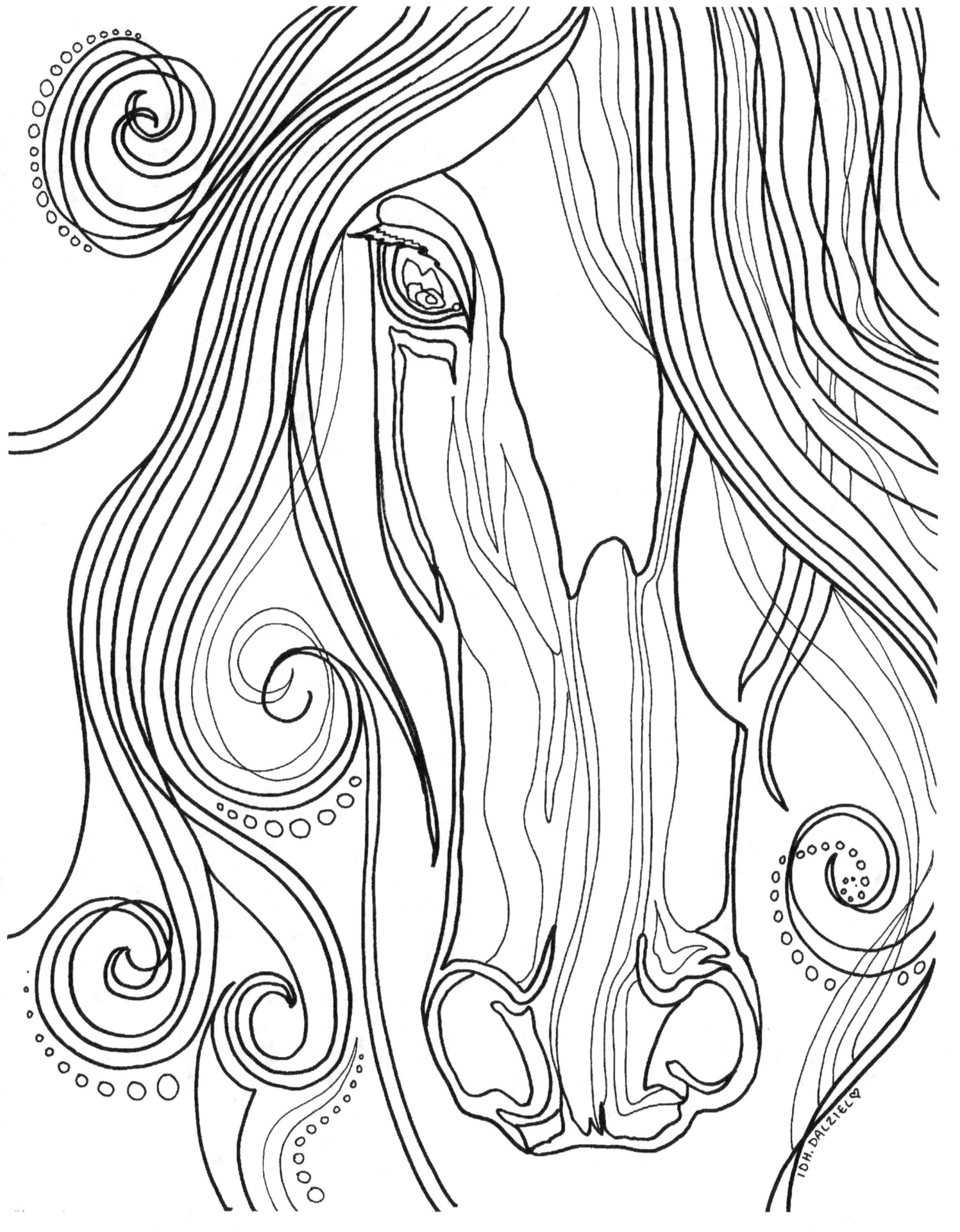

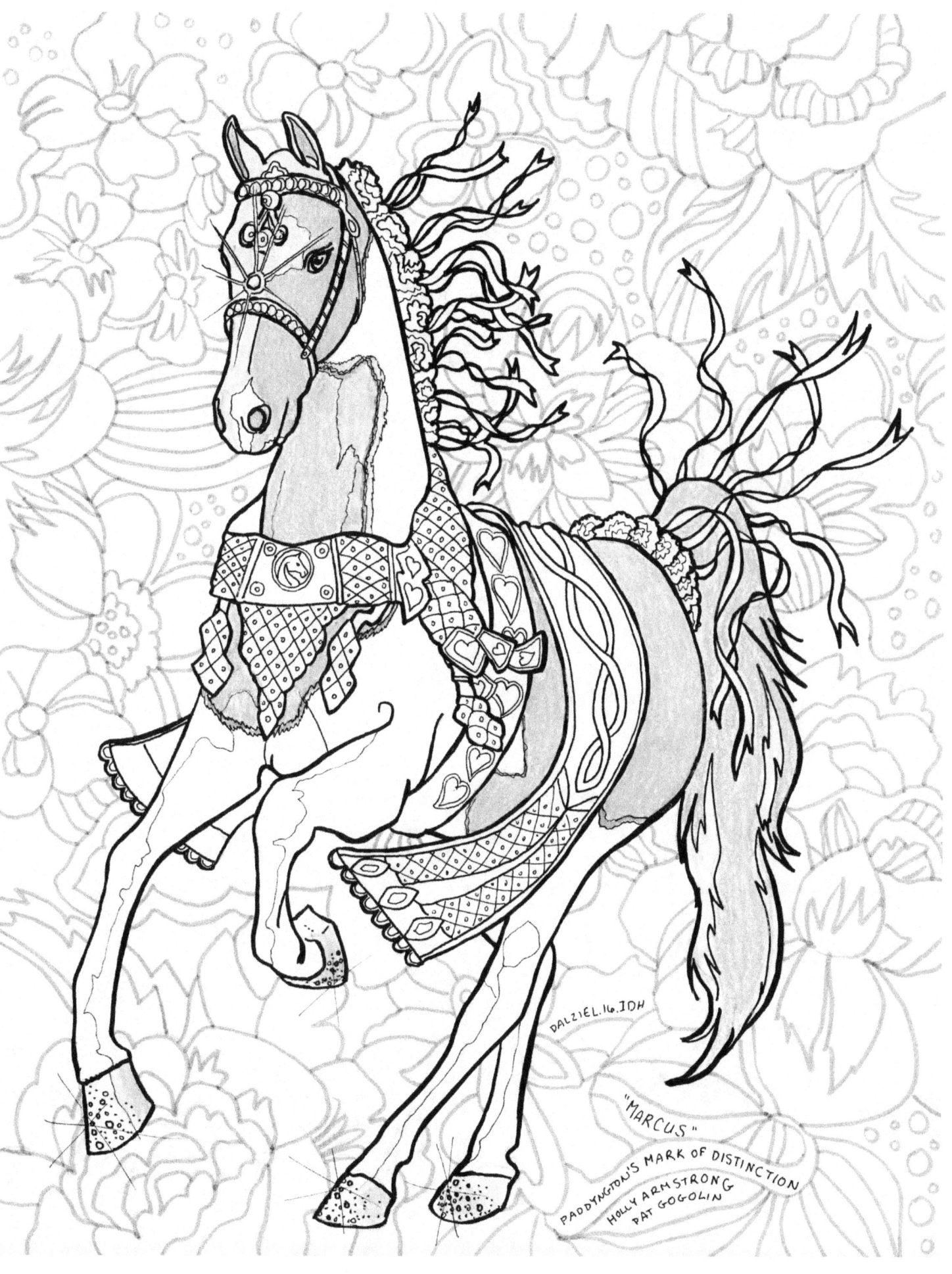

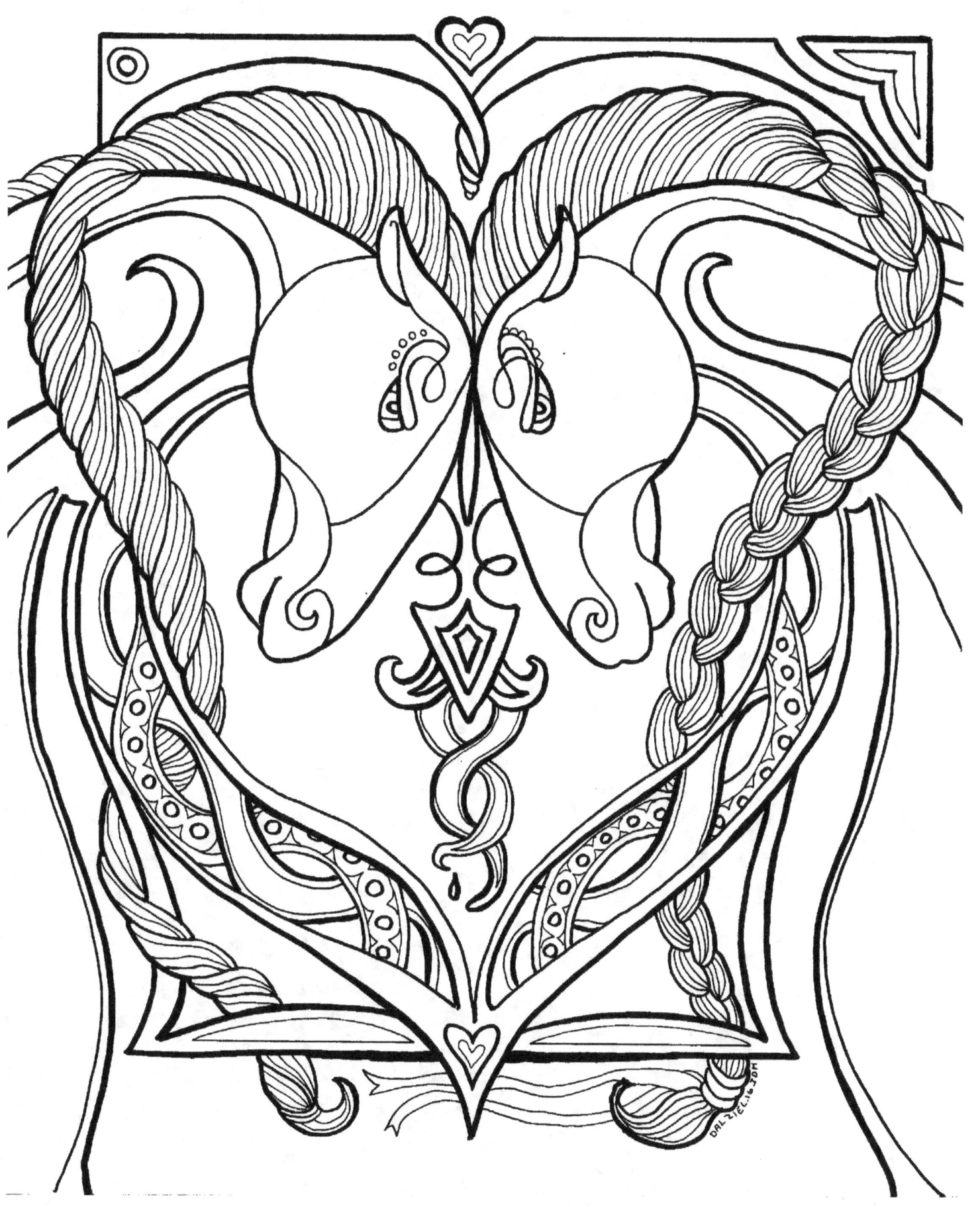

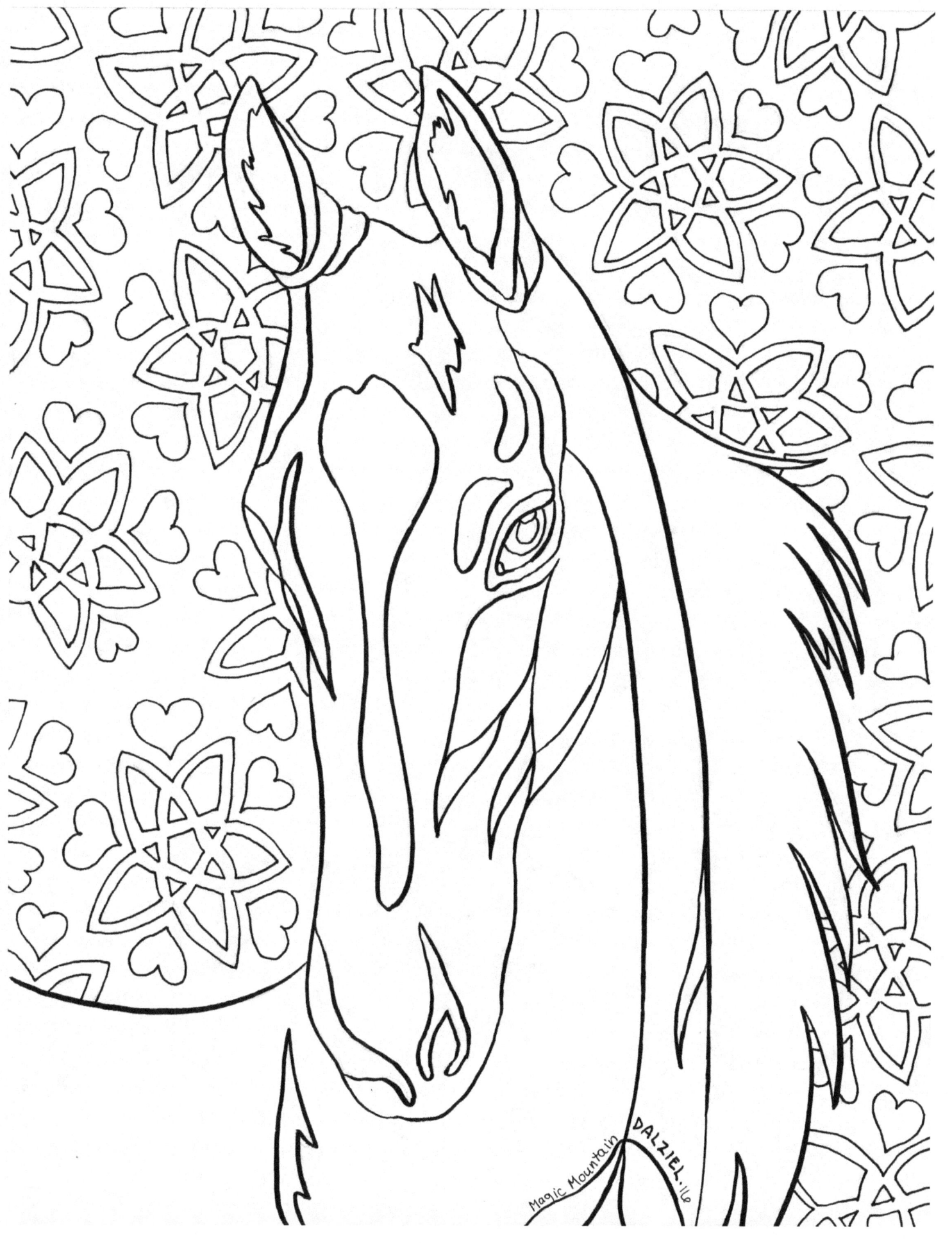

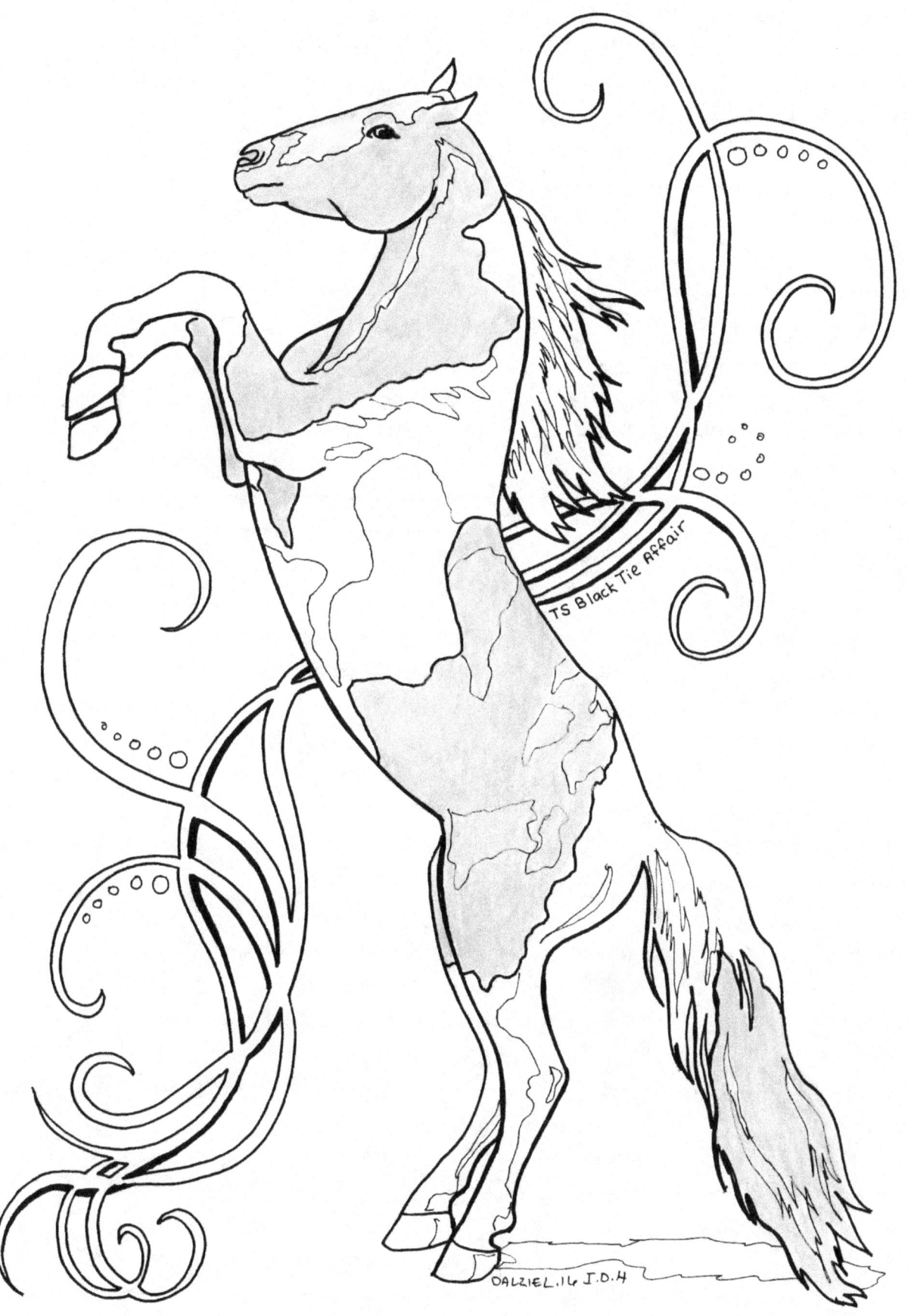

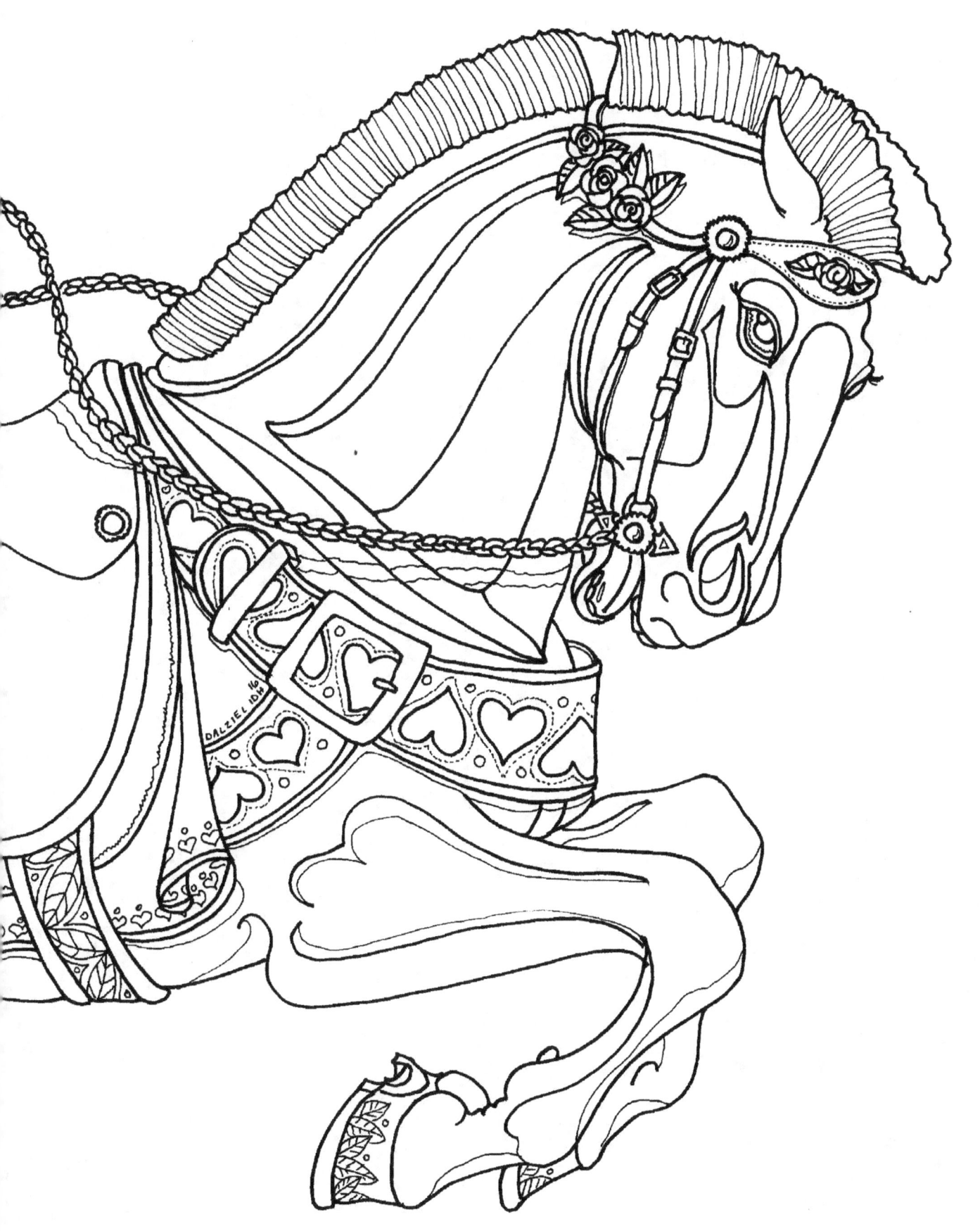

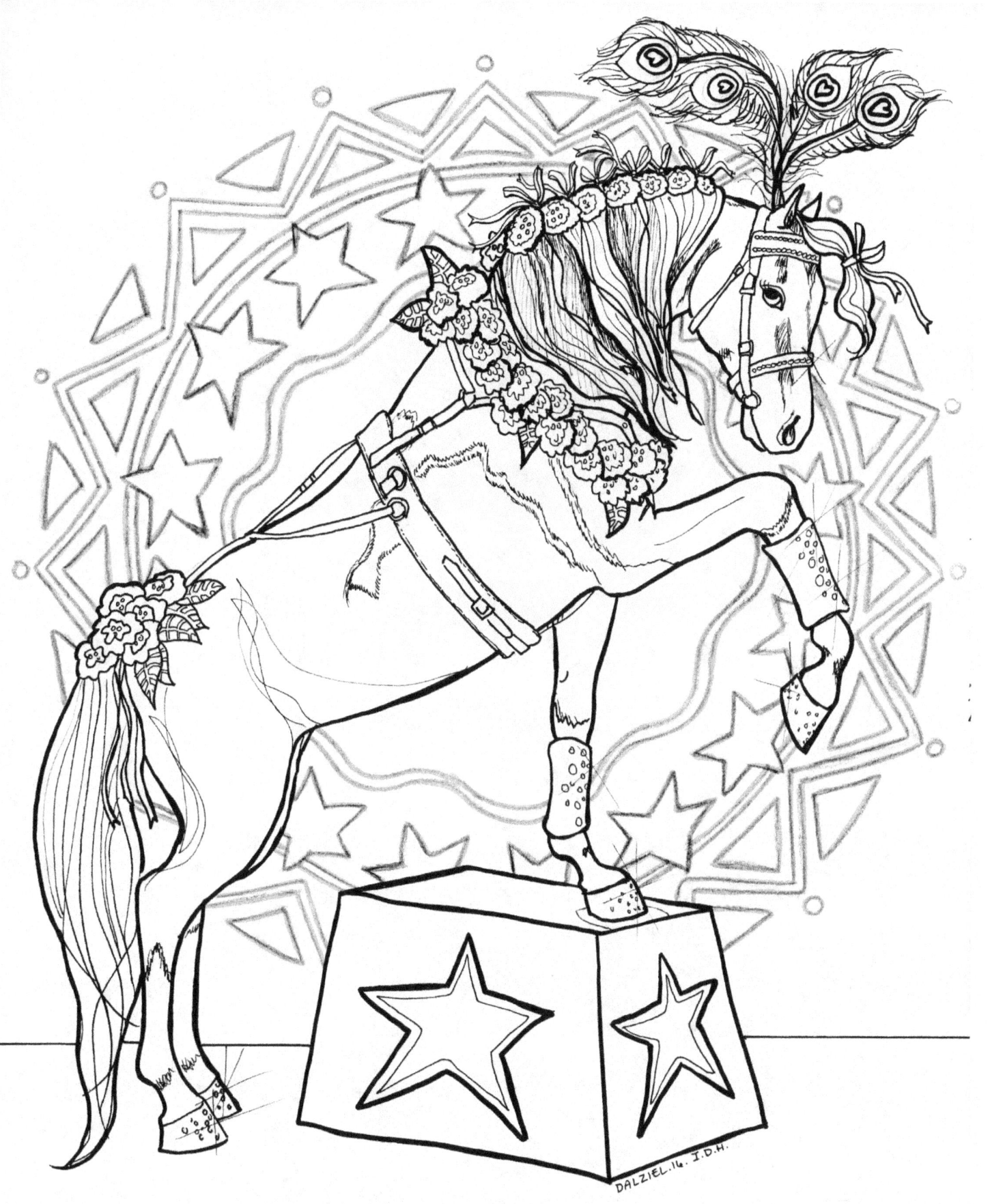

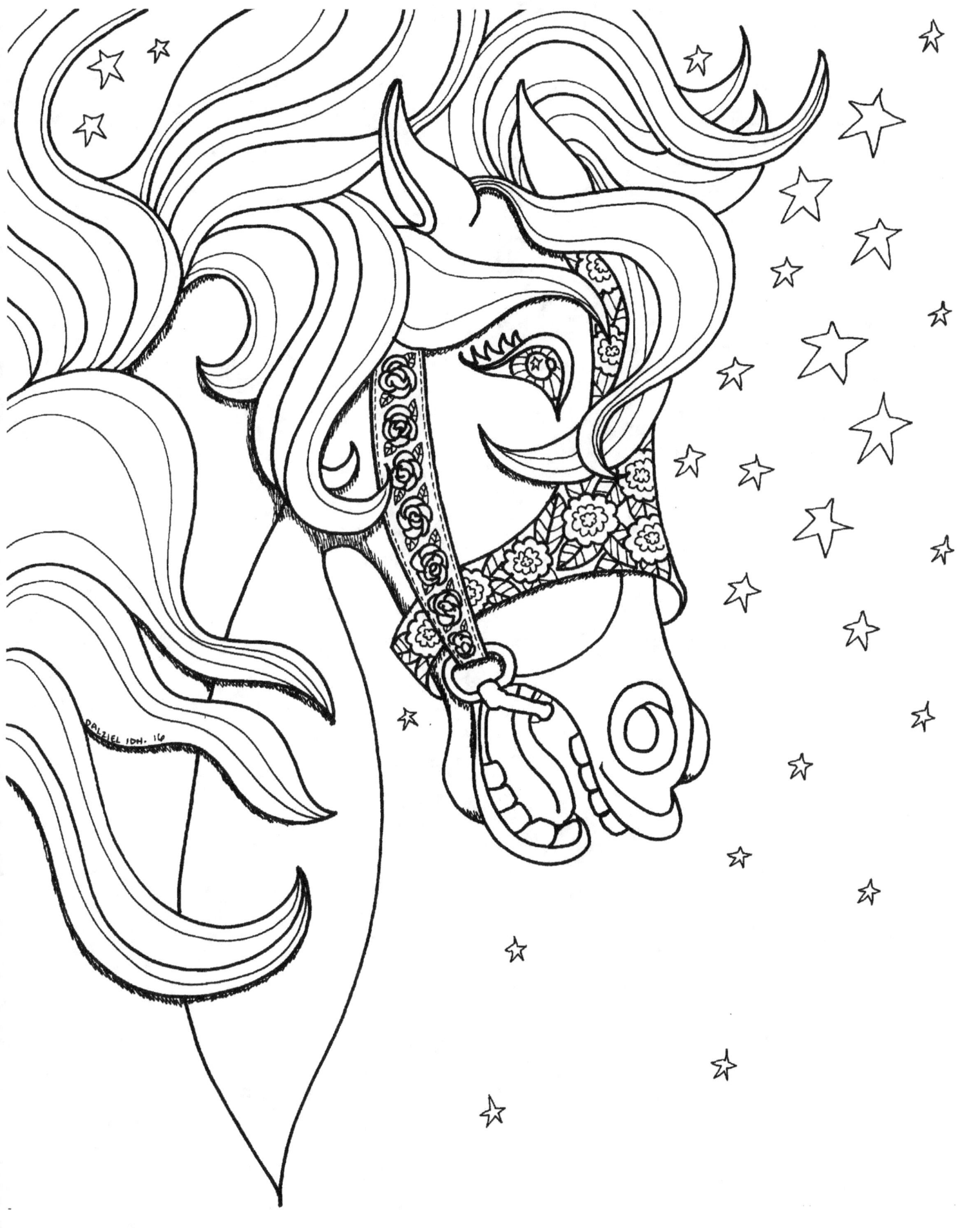

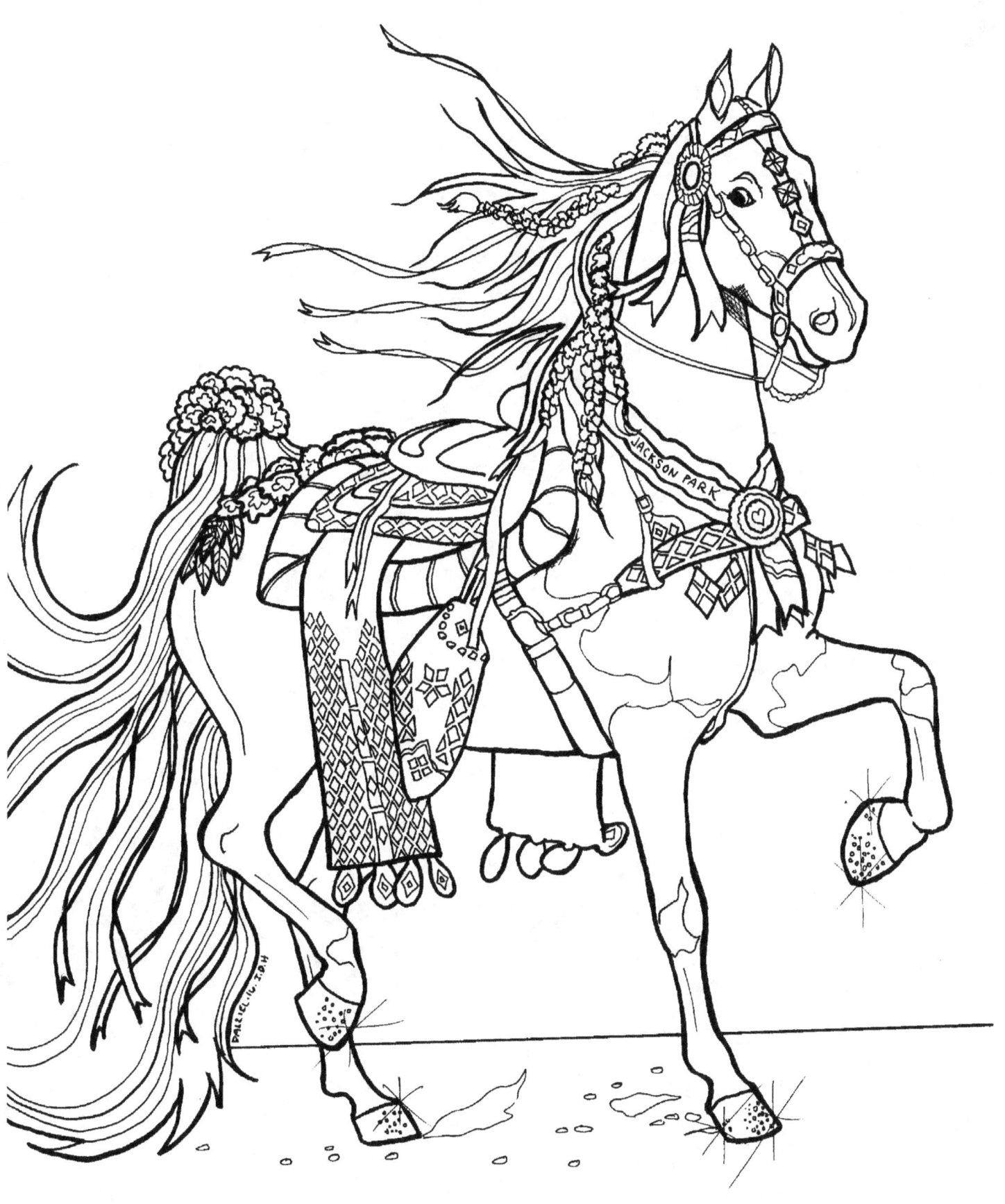

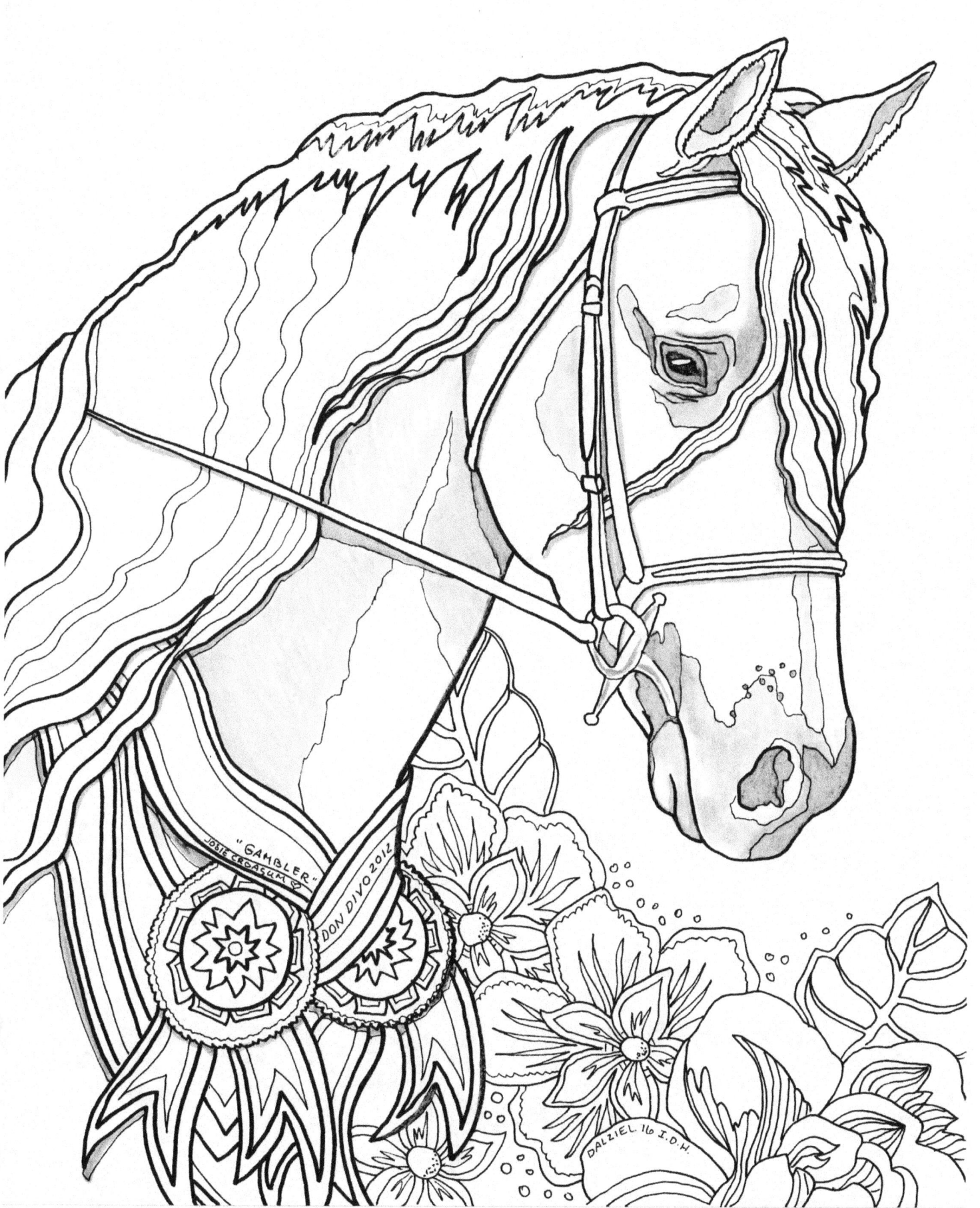

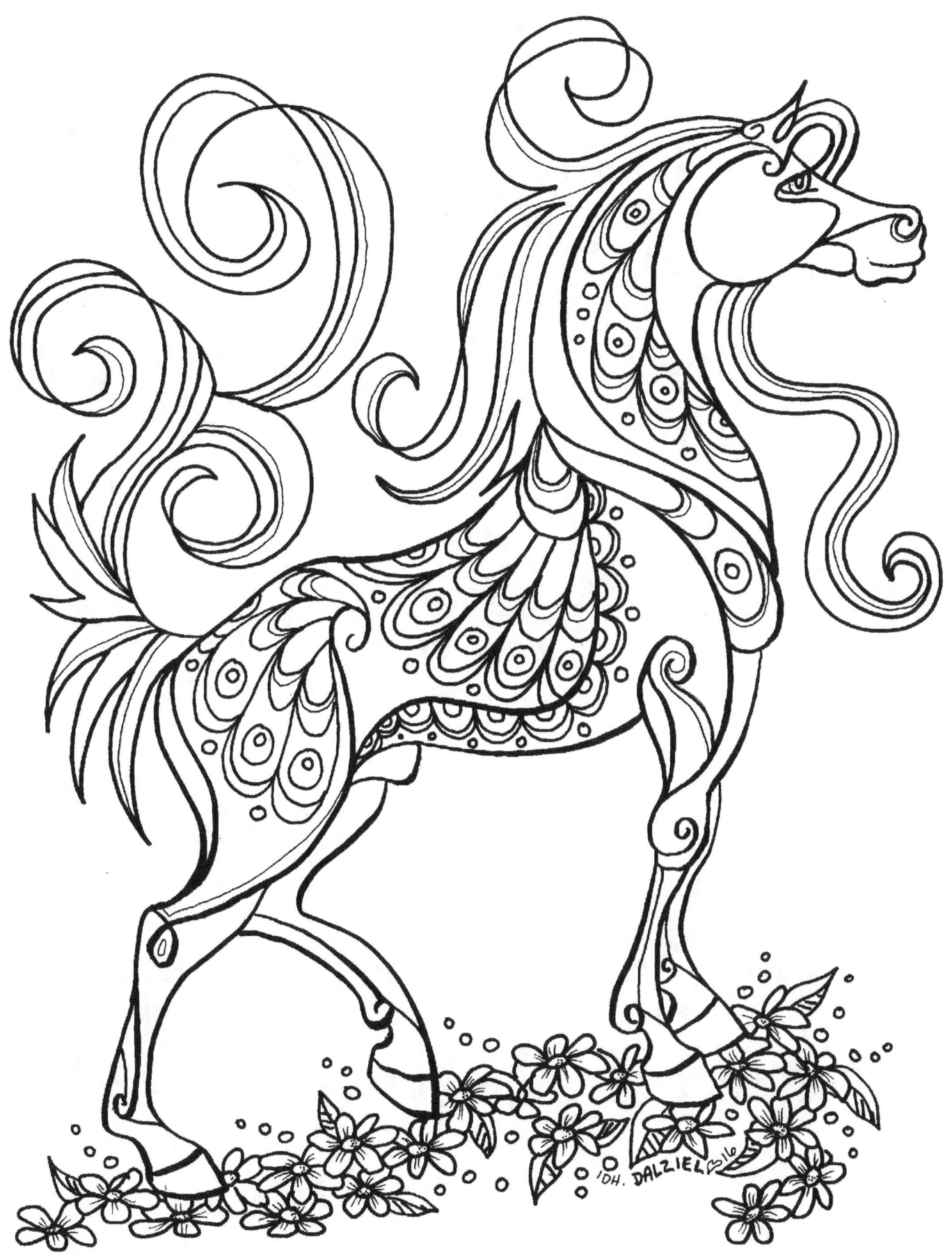

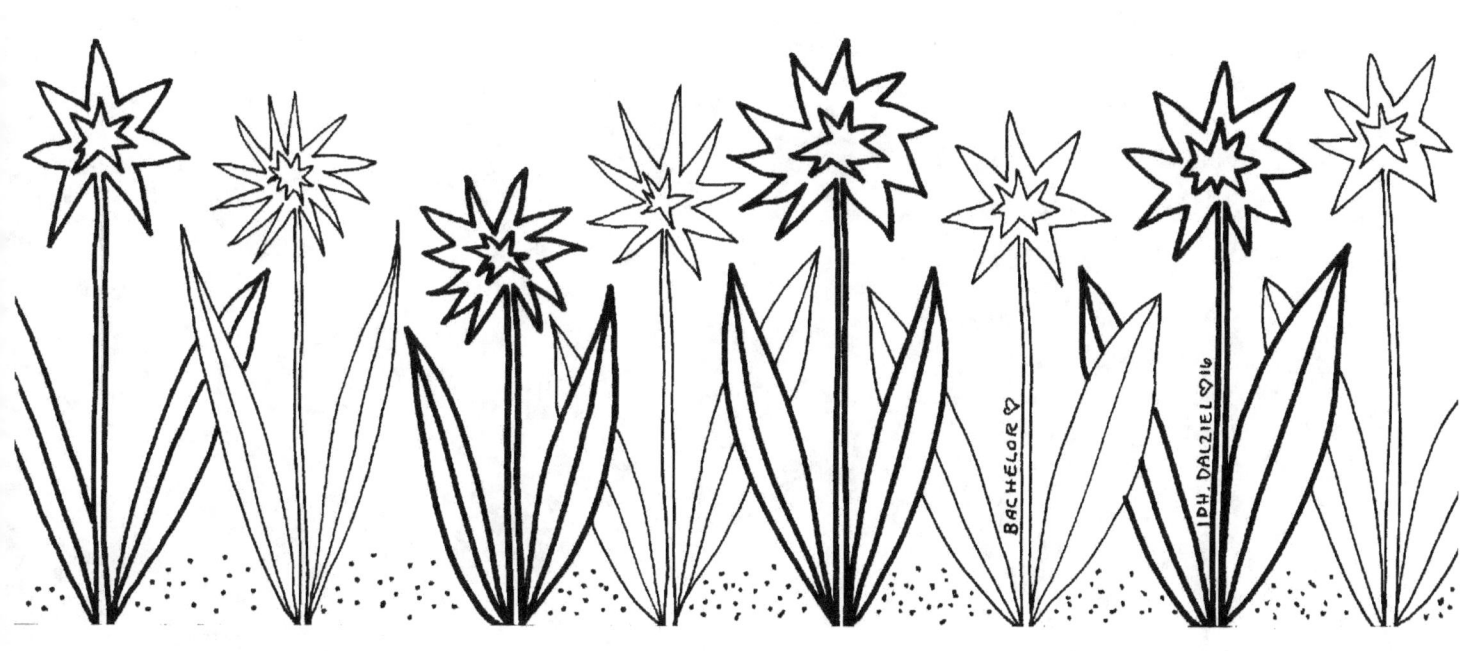

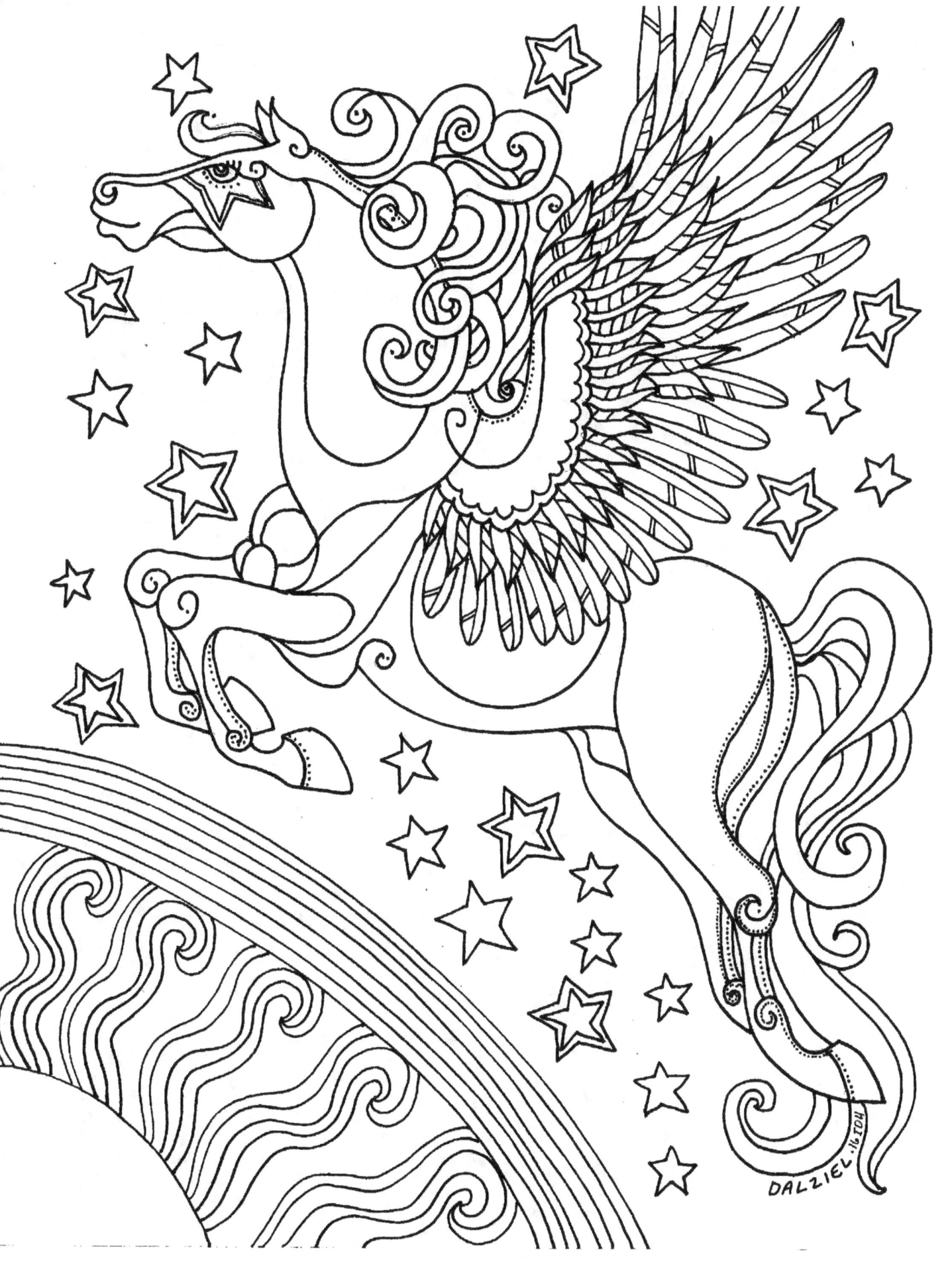

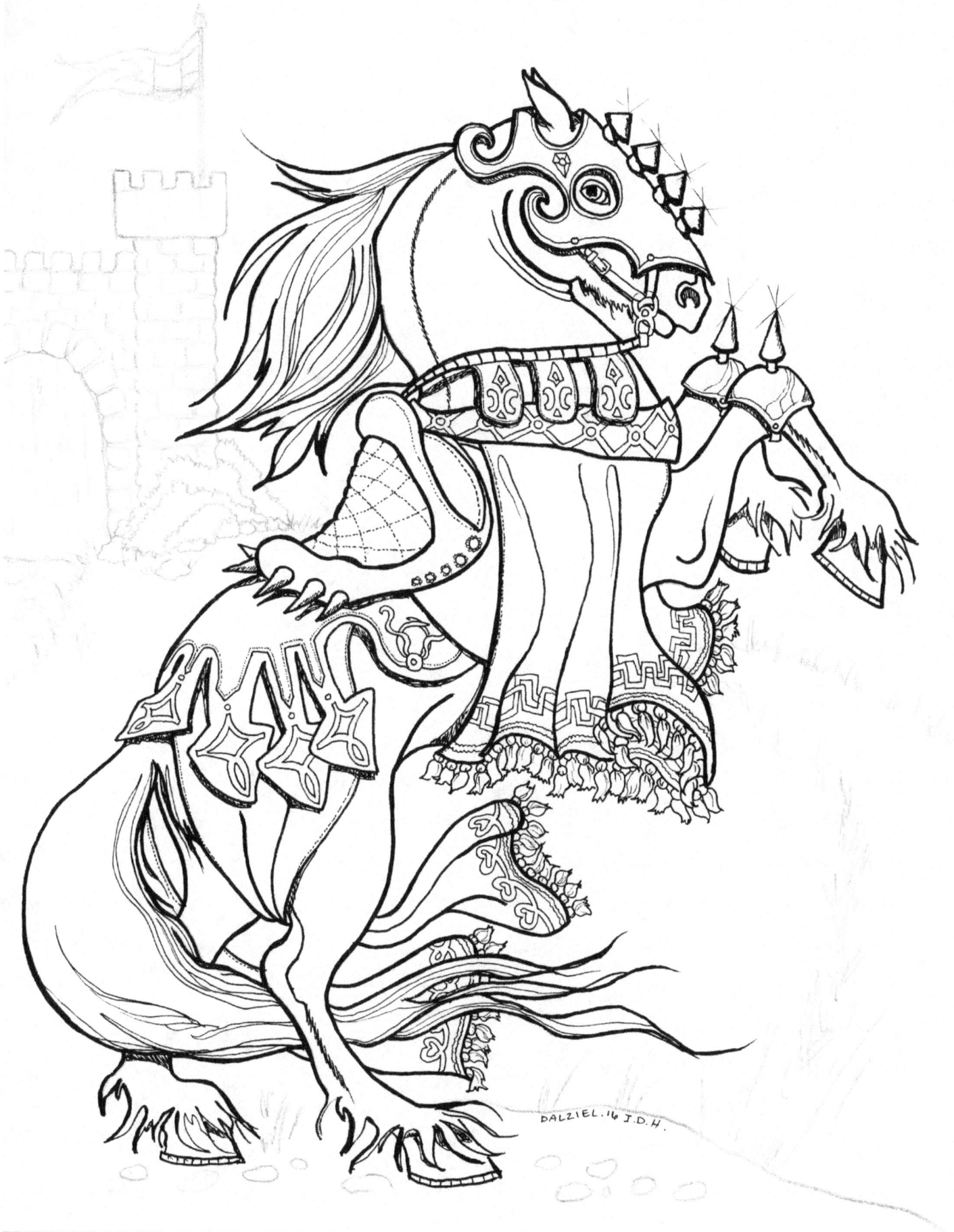

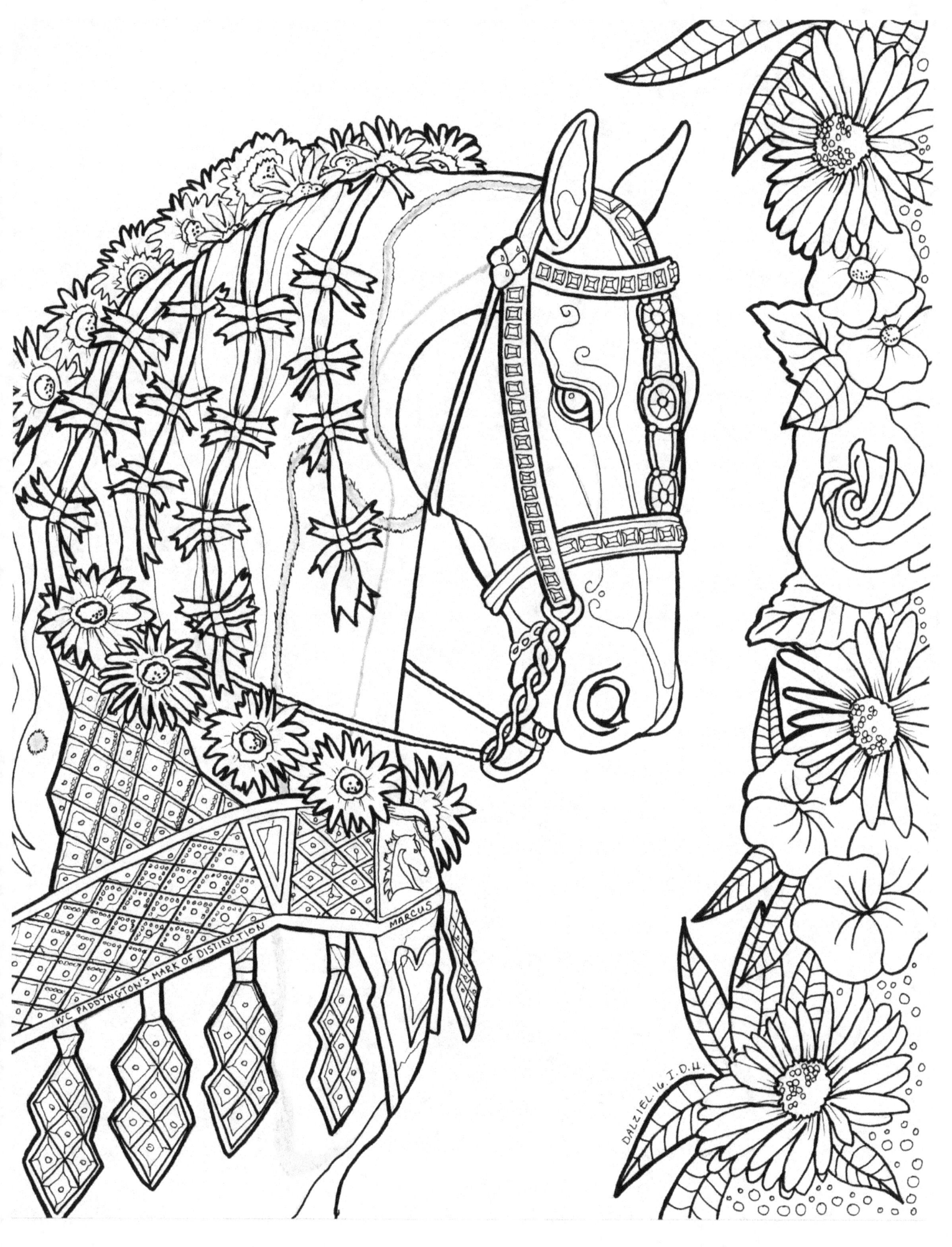

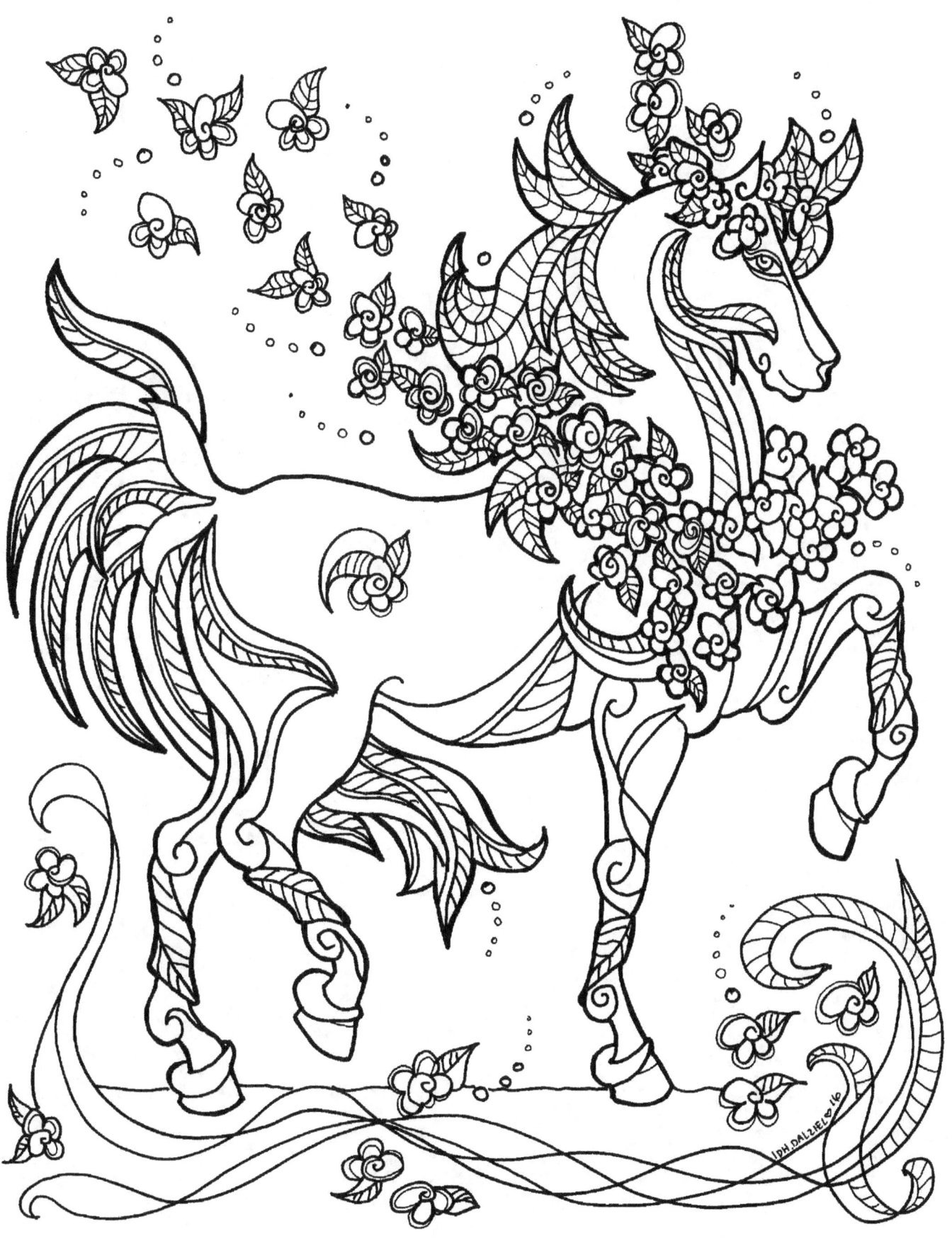

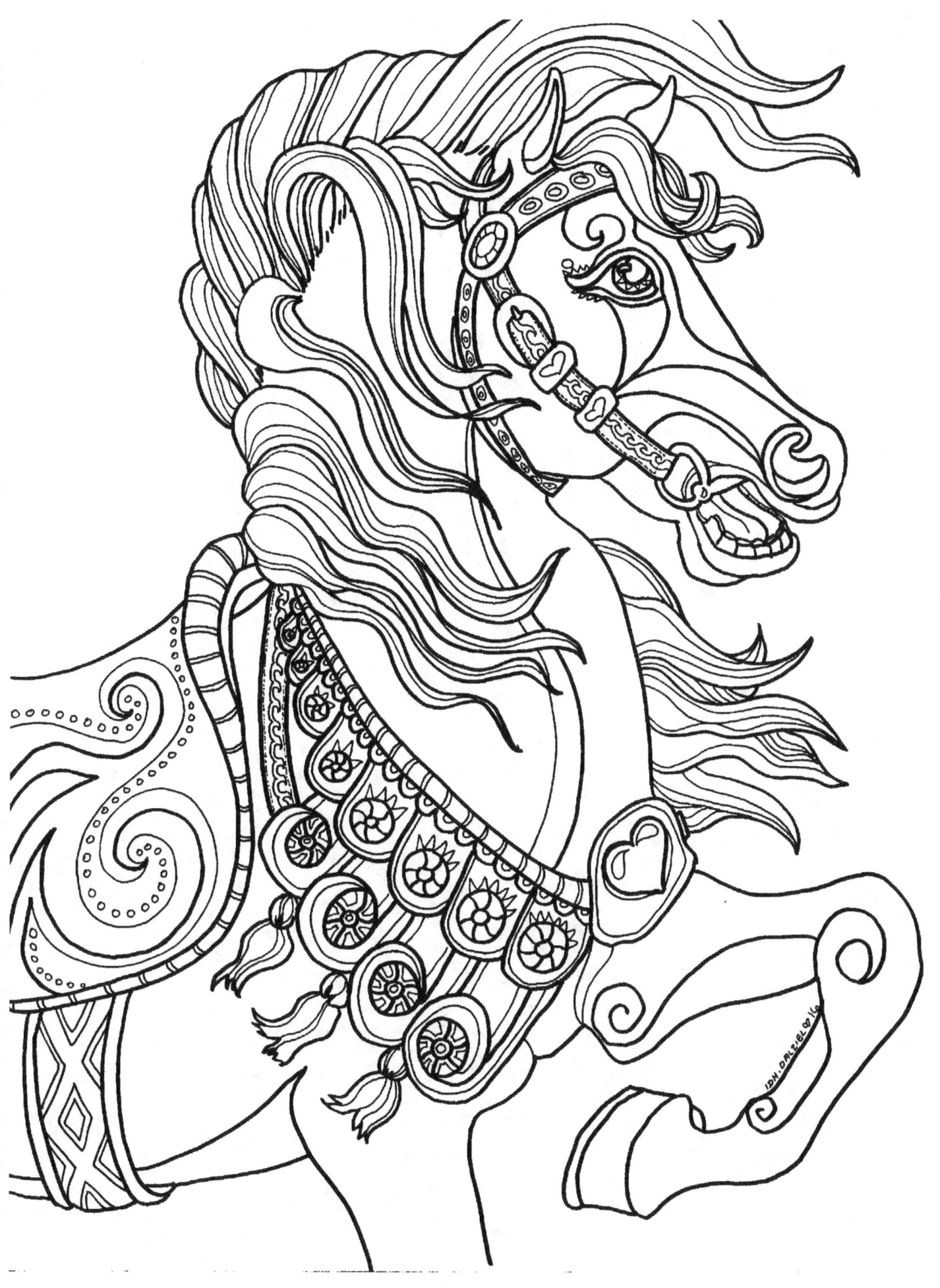

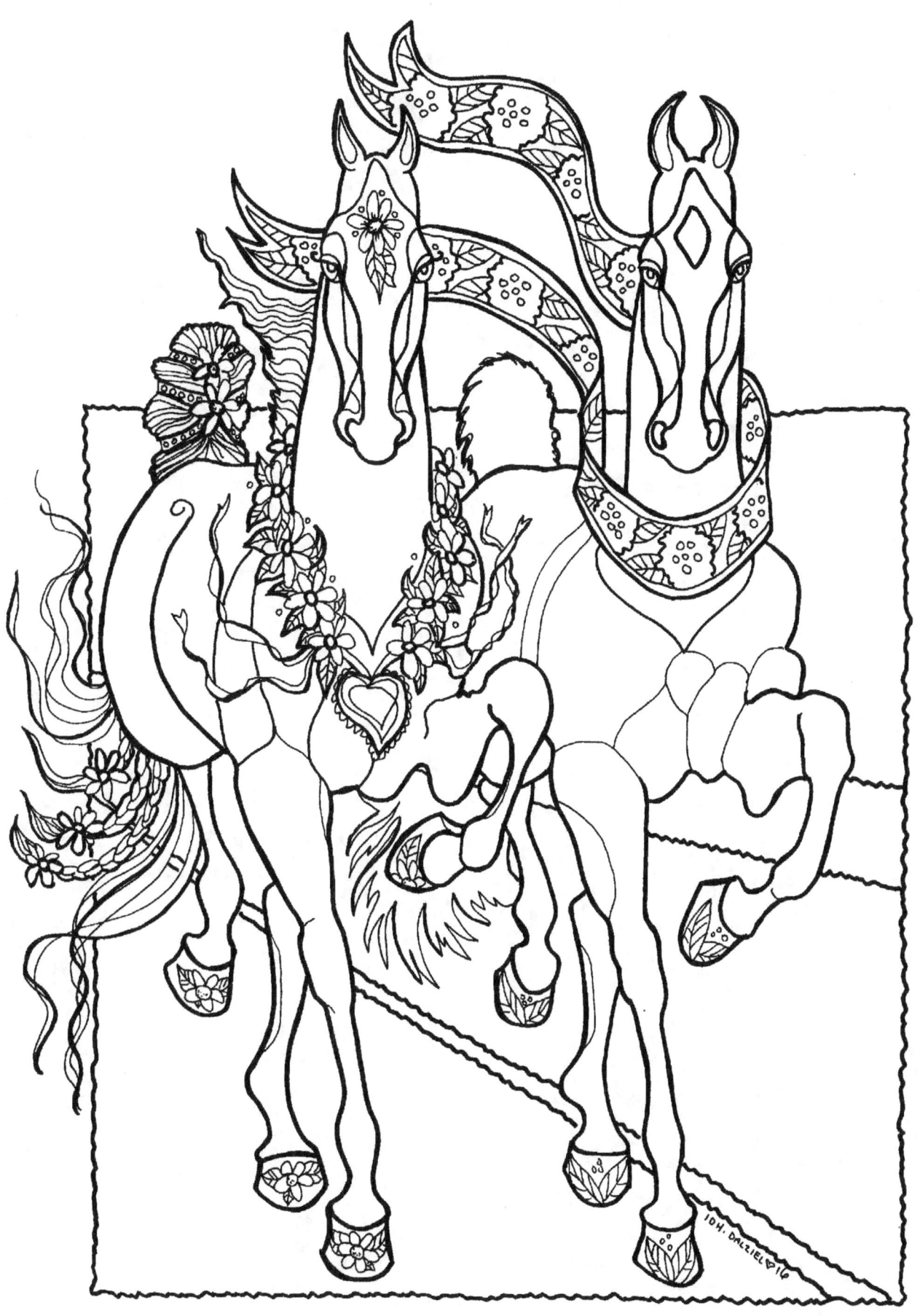

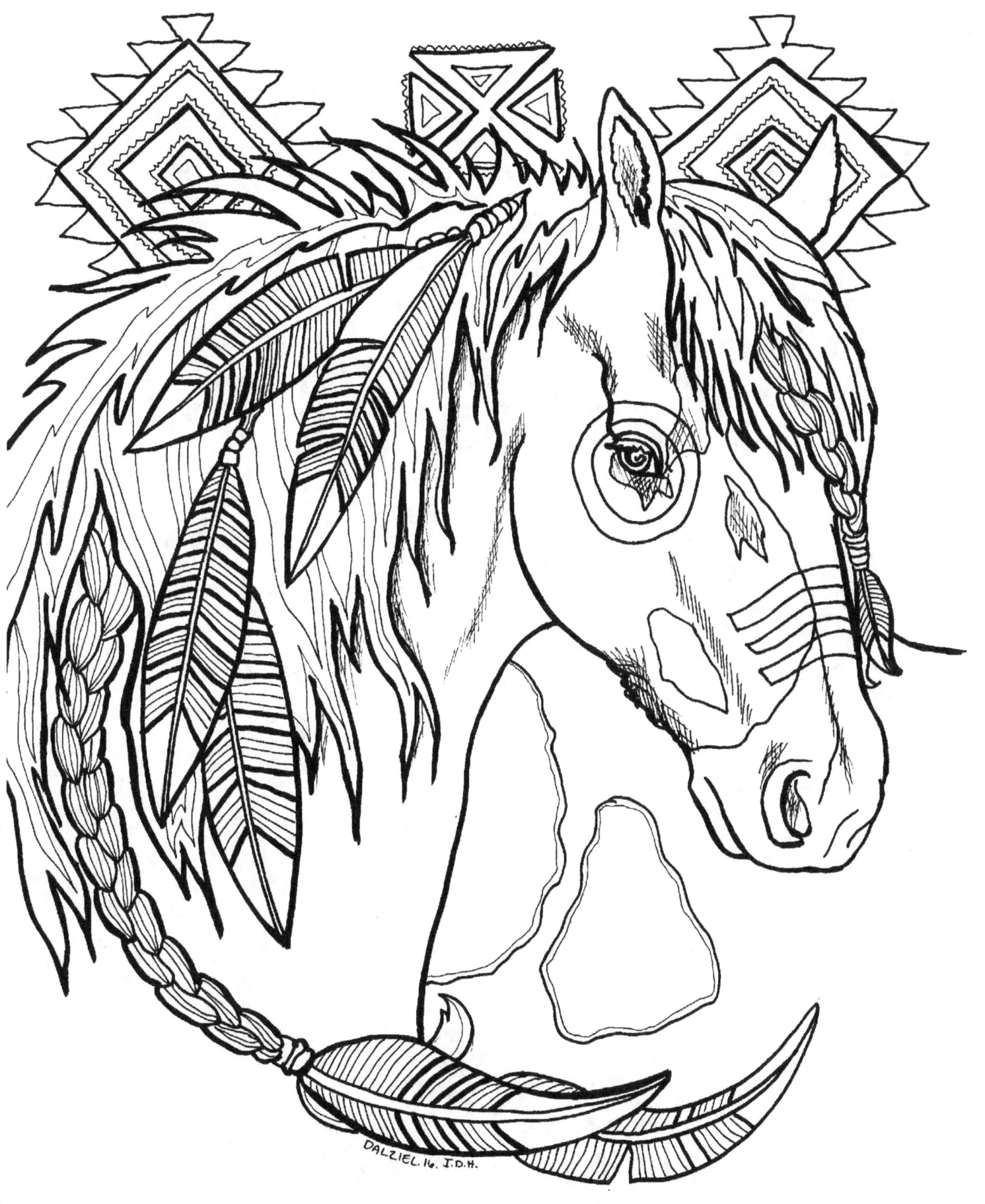

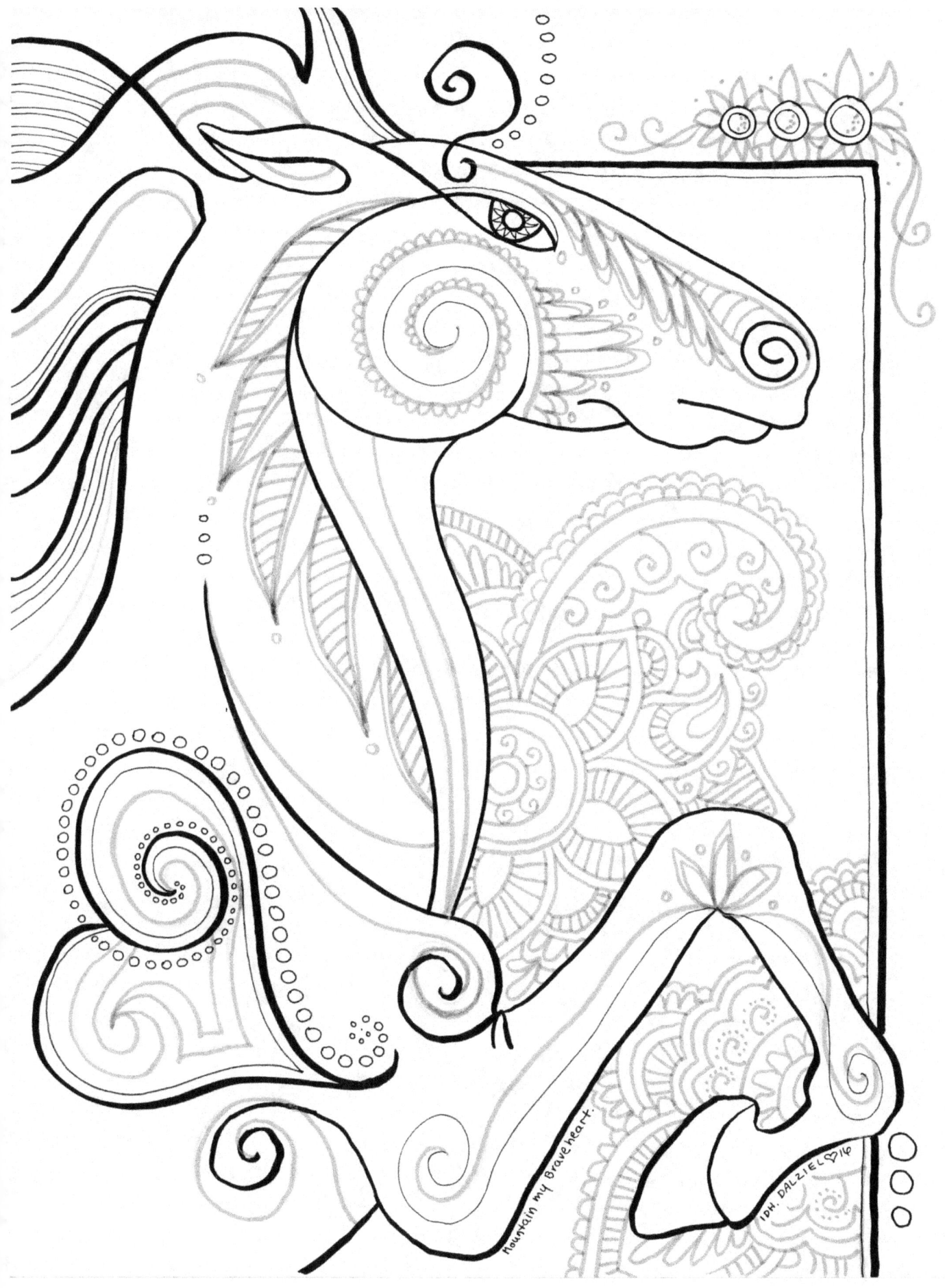

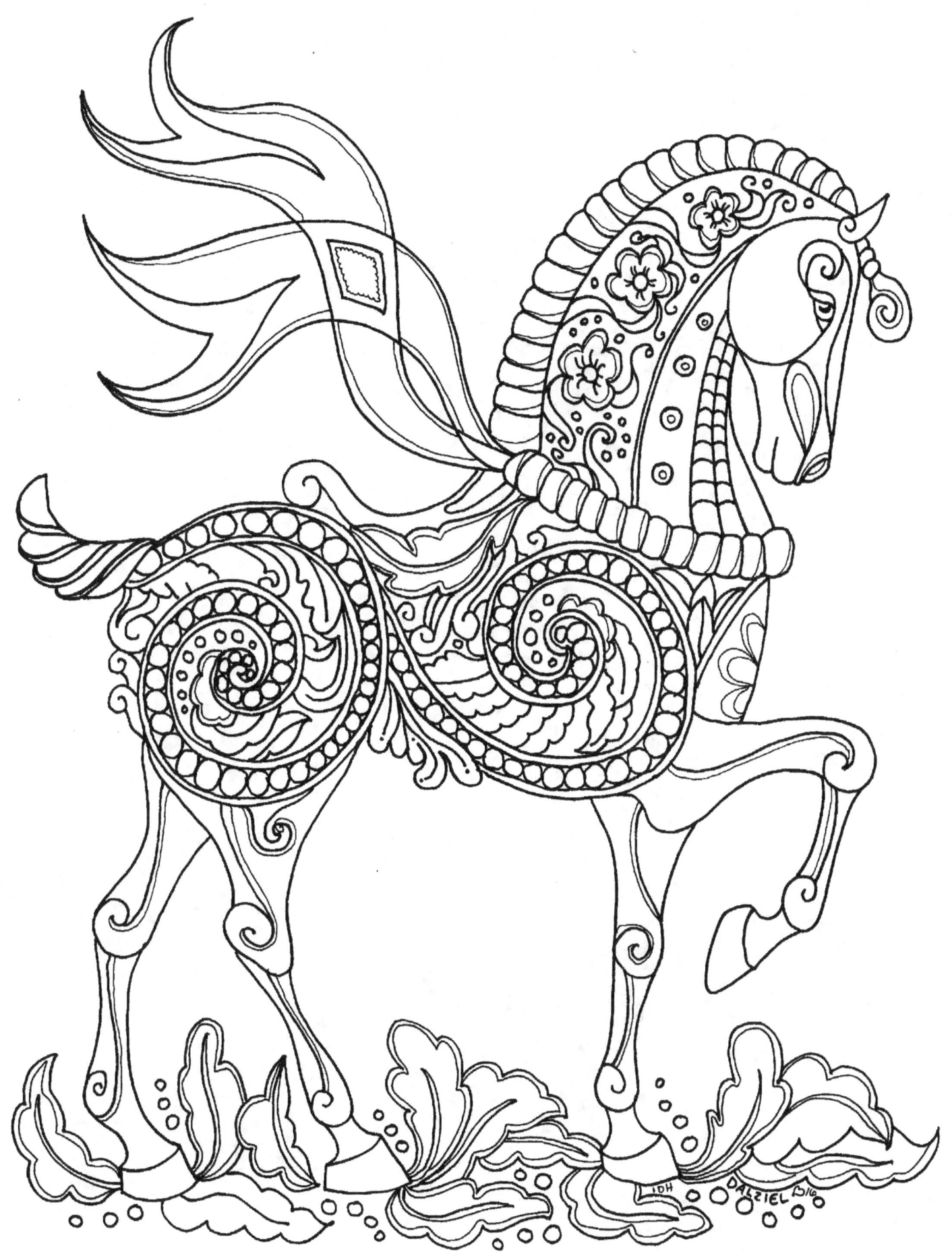

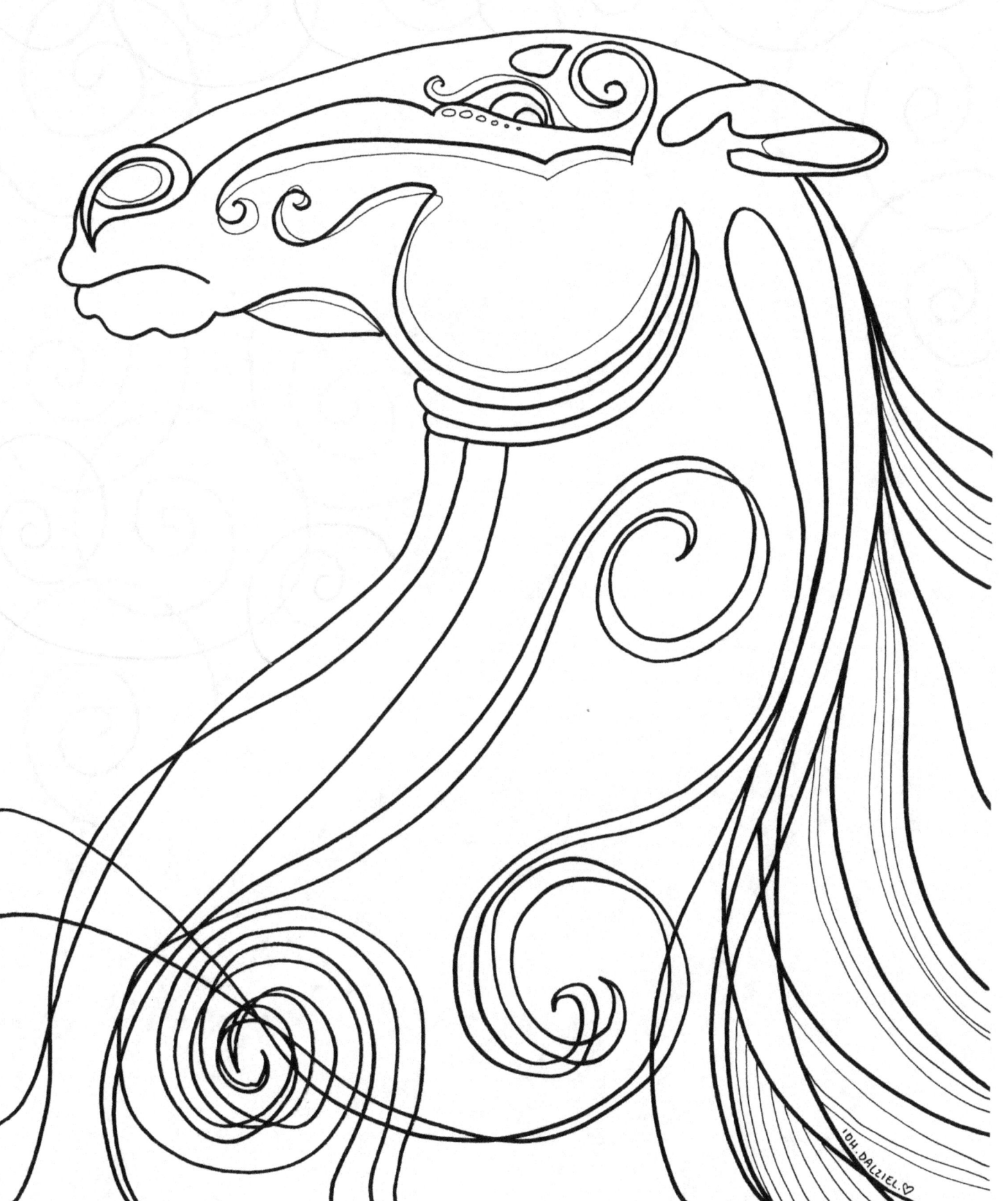

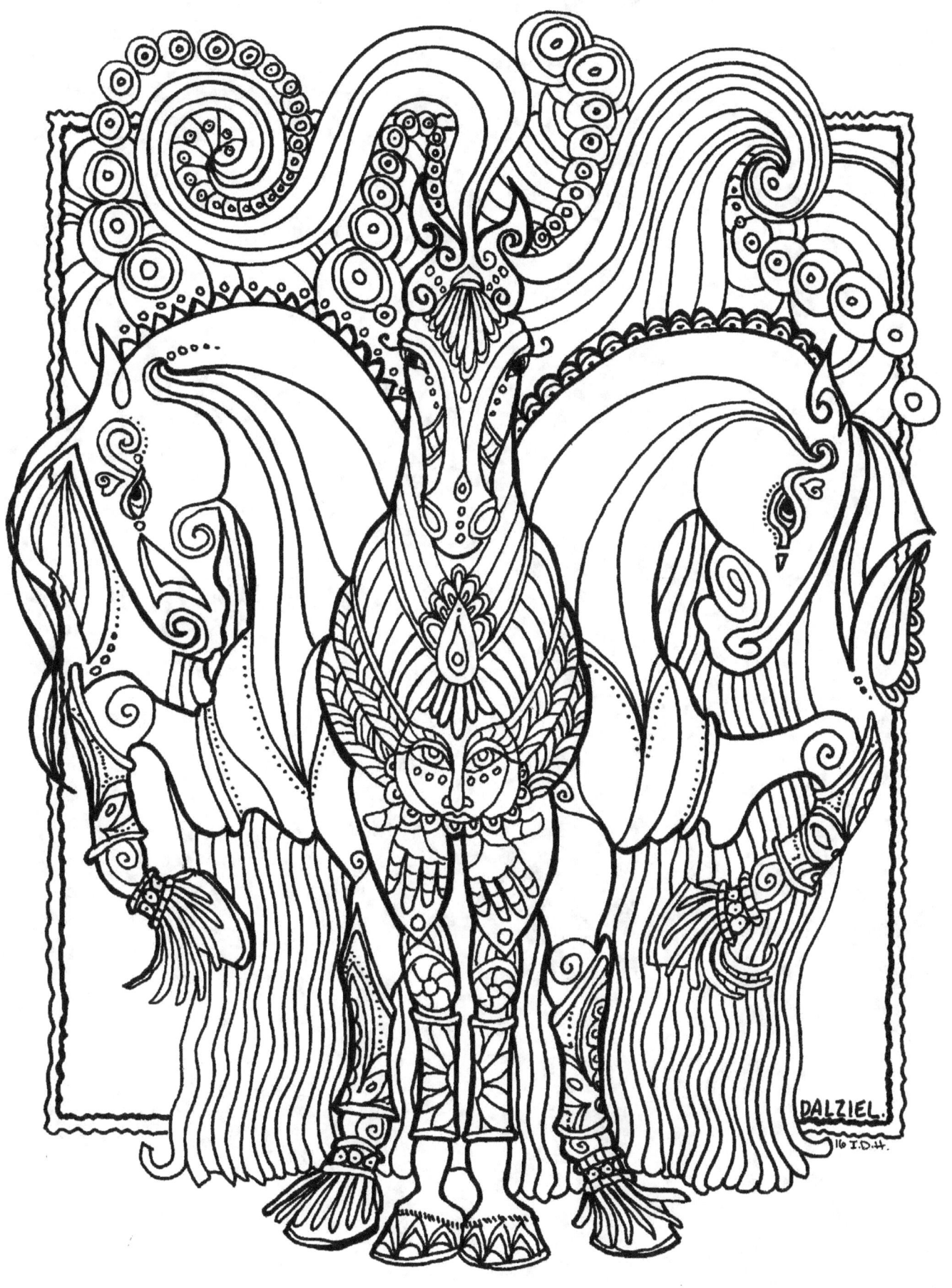

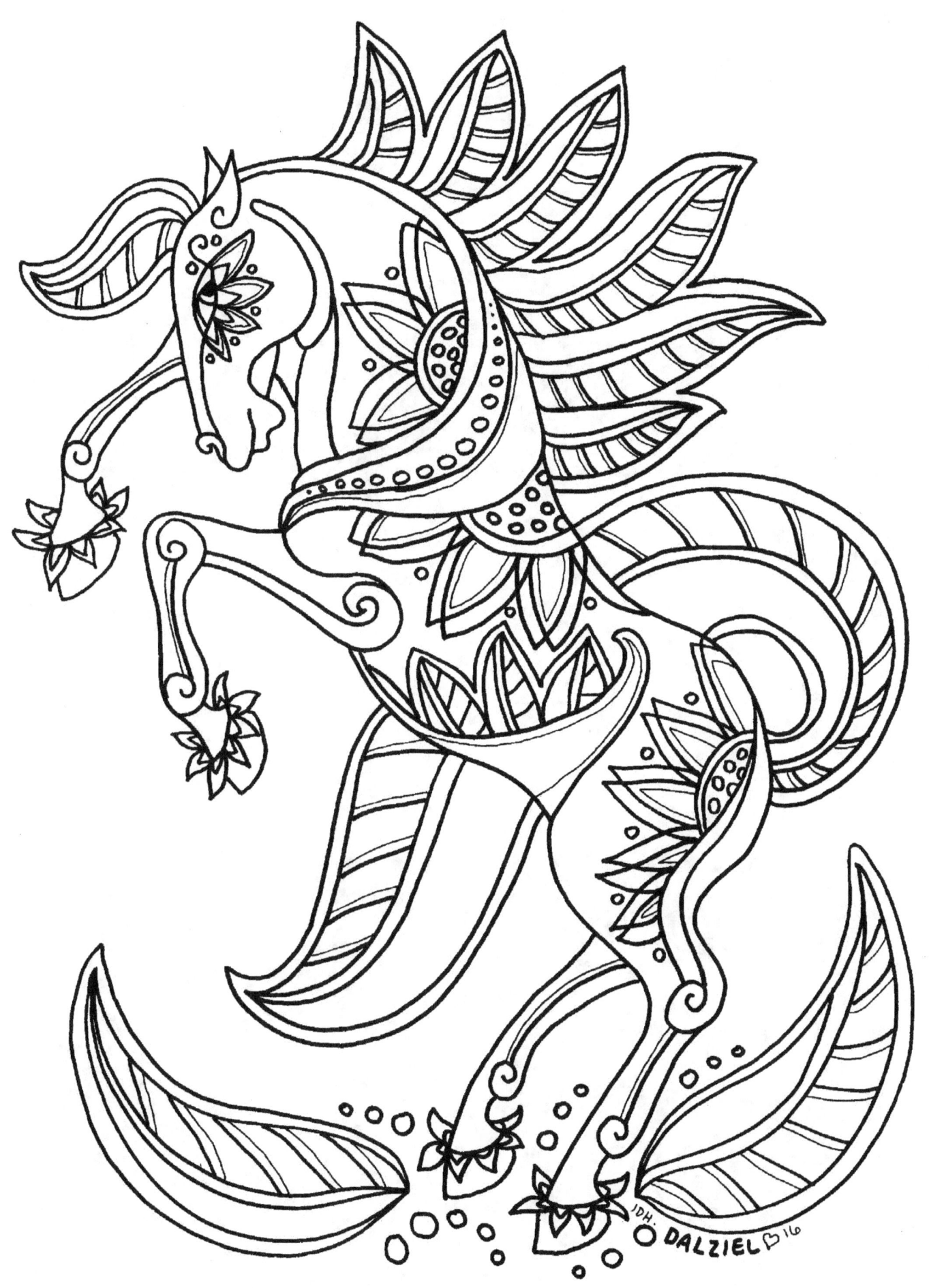

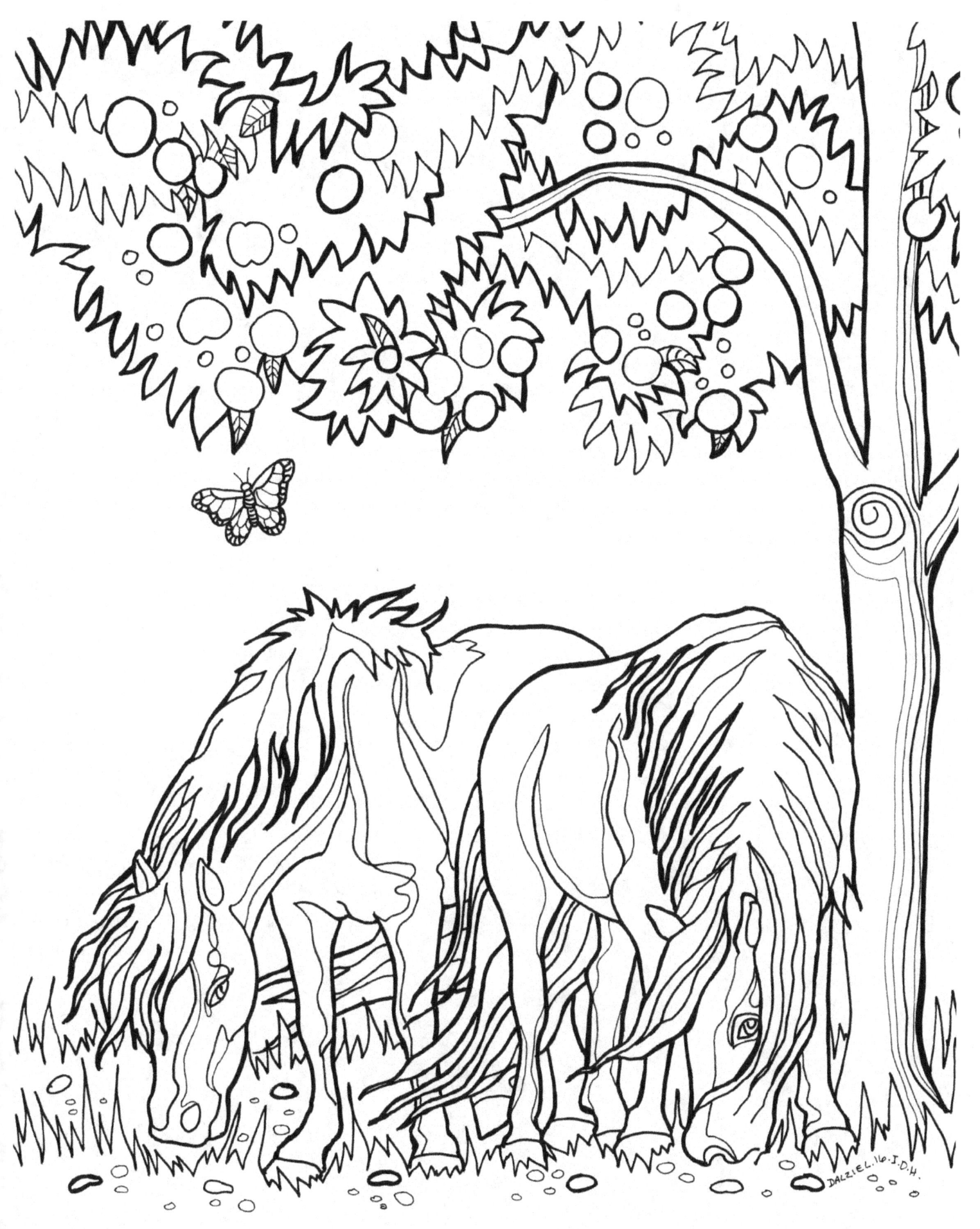

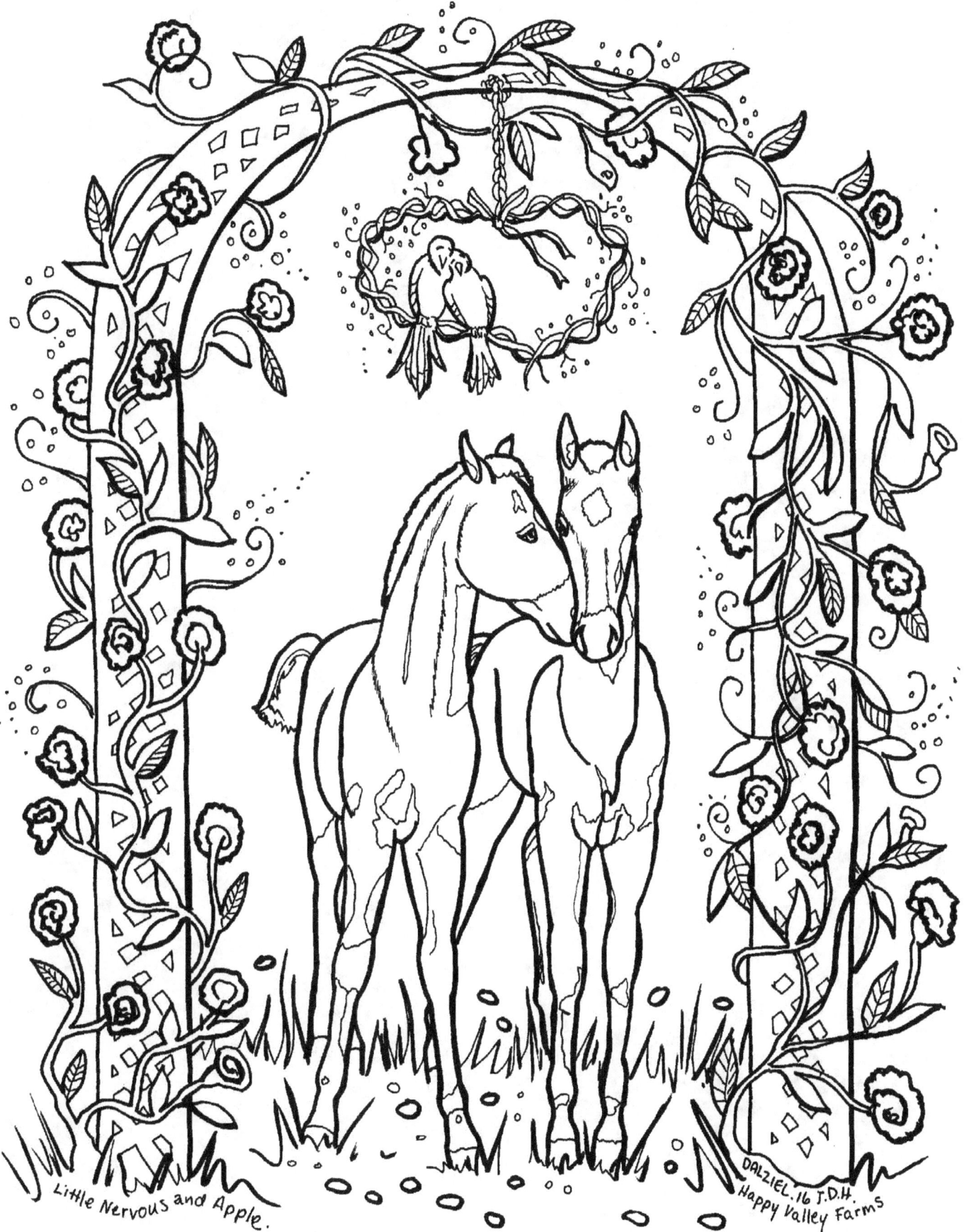

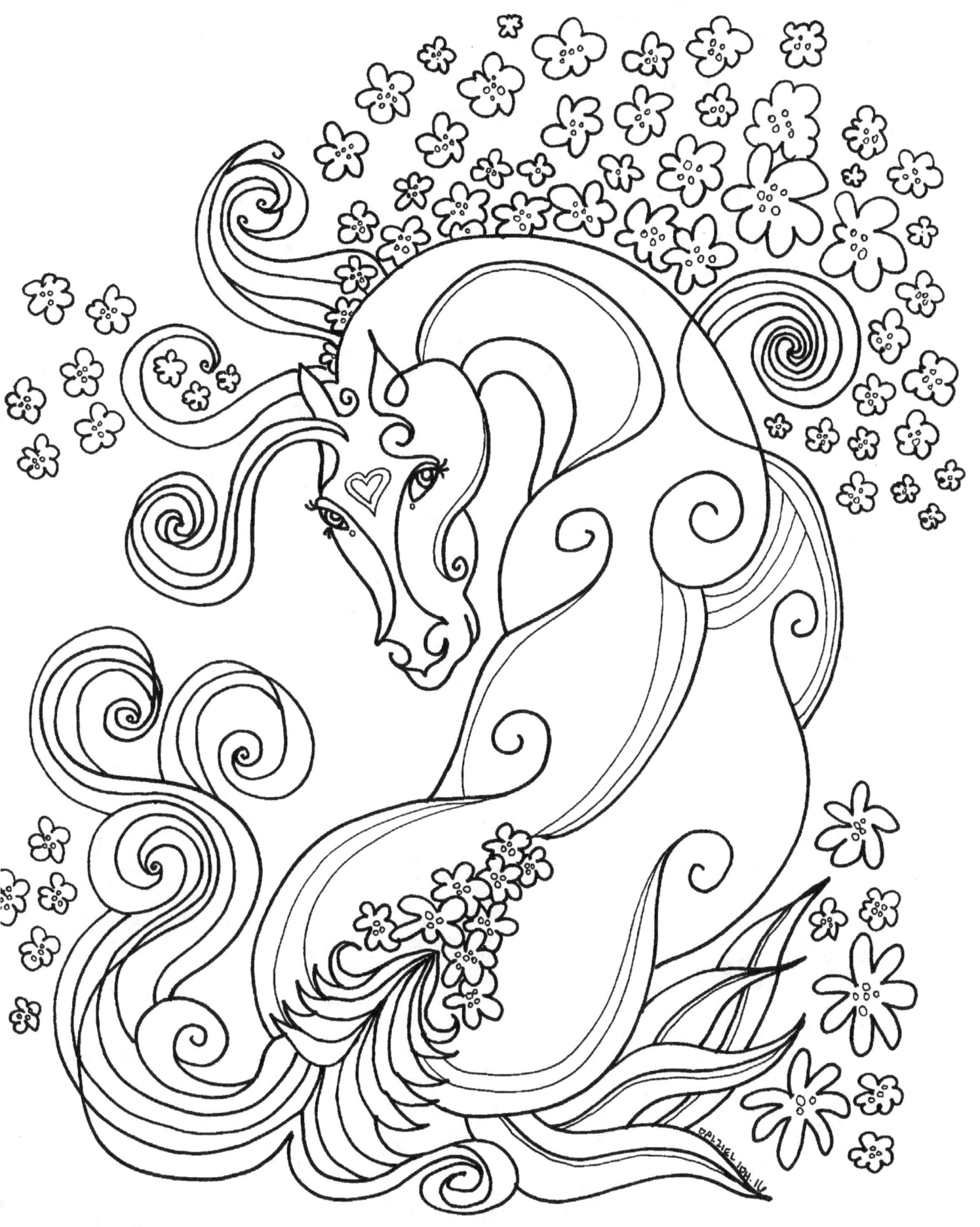

I dream horses! I always have, I am sure I always will.
And I know you do too!
What started out to be a vision to create a beautifully illustrated horse coloring book out of my imagination just to make my own heart sing, quickly turned into a unique collection of designs inspired by horses from people everywhere. I even made new friends in the process as horse lovers shared their gorgeous equines with me for inspiration. Friendships that I know will last a lifetime because we were all brought together through the heart of Equus.

I would like to thank the following people and farms for letting their beloved magical horses be a part of this wonderful coloring book, as well as special thank you's for kindness and support in helping me make it happen:

Kathy Kerr
WC PADDYNGTON'S MARK OF DISTINCTION "Marcus"
Meadow Reflections Farm, Holly Armstrong, Patrick Gogolin (photo references)
LITTLE NERVOUS AND APPLE, Happy Valley Farms
Bit Hutcheson, Jill M. Huskey (Photo references)
JACKSON PARK, JAM Stables, Mike and Jennifer Cunningham
TS BLACK TIE AFFAIR
DARKER N BEY, Pinto Park, Jan Sharp
VIÑOS OLIMPO, "Vino" Provenance Dressage, Deborah Ann Polec, Yin You (photo reference)
DON DIVO "Gambler", Josie and Cheryl Croasum
VIRTUAL ADVENTURE, "Vinnie" J. Bennett Farms, Missy Bennett
REEDANN'S HIGH PHLIER, "Harley" Amy Clendaniel
PRETENDER, Kira Elyse, Jennifer Granger
MY BACHELOR, Laura Briggs Thatcher
J.Bruce Jones BrucetheBookGuy.com
Evenådalen Ranch, Shandi Bech: colored page, back cover

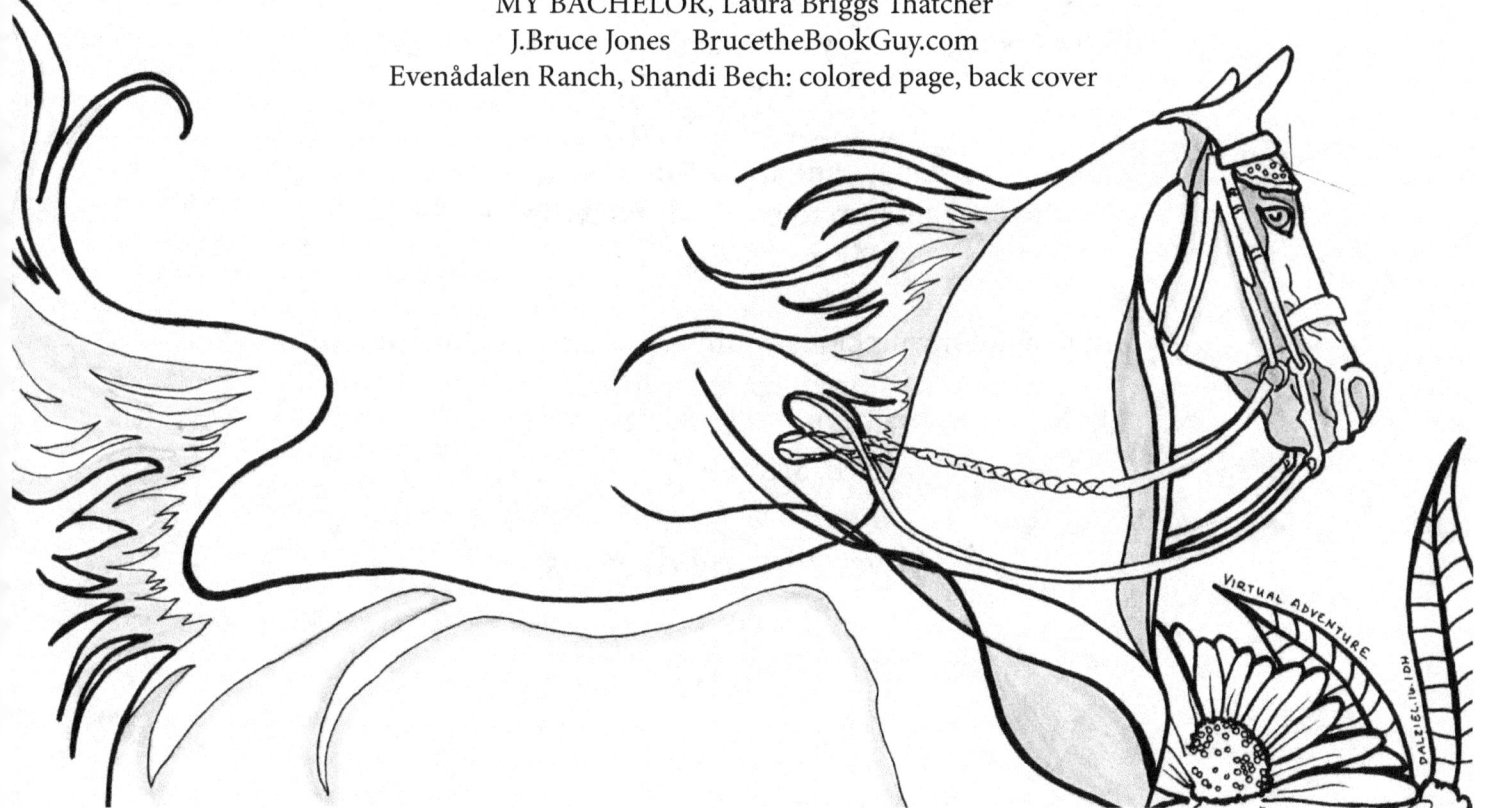

ABOUT THE ARTIST

LINDA DALZIEL came into this world passionate about horses, animals, art and music.

Holidays and birthdays were filled with Breyer horses, coloring books, sketch pads and fresh boxes of crayons. She excelled in music and the arts all through school.

Linda now enjoys a diverse career in everything she loves. Her successes as a singer, songwriter, producer include world tours, national television and radio commericals, television appearances and movie soundtracks.

She has enjoyed several successful art shows, paints life sized horses on canvases, is a well known pet portrait artist, illustrates with a whimsy and now creates coloring books for all to enjoy.

Linda joyfully follows her heart, living the California dream with her dogs, her horses in spirit, and a parrot that meows.

ARTIST'S DEDICATION

This book is lovingly dedicated to my beloved horses
MAGIC MOUNTAIN
who made this all possible,
and to SABRE
who brought him to me, and stands beside him.
My guardian angels.

And to all of my precious equines who came before them,
loved just as dearly:
GINGER, KAYDIN, DUKE
SNOWFIRE, SILVER AND FLICKA.

Always in my dreams.
Forever,
I Dream HORSES.

COLORING TEST PAGES

Try your colors here first to see how they will act on the paper and if they will bleed. Experiment and have fun!

COLORING TEST PAGES